IMAGES
of America

CEDAR GROVE

To Marilyn and Dick Craine, October 2000
Hope you enjoy this trip down the river,
roads, and rails of yesterday's Cedar Grove.
Best wishes,
Phil Jaeger

IMAGES
of America

CEDAR GROVE

Philip Edward Jaeger

ARCADIA

Copyright © 2000 by Philip Edward Jaeger.
ISBN 0-7385-0452-1

First printed in 2000.

Published by Arcadia Publishing,
an imprint of Tempus Publishing, Inc.
2 Cumberland Street
Charleston, SC 29401

Printed in Great Britain.

Library of Congress Catalog Card Number: 00-104063

For all general information contact Arcadia Publishing at:
Telephone 843-853-2070
Fax 843-853-0044
E-Mail sales@arcadiapublishing.com

For customer service and orders:
Toll-Free 1-888-313-2665

Visit us on the internet at http://www.arcadiaimages.com

This book is dedicated to three people who meticulously chronicled Cedar Grove's past—Samuel Ward Boardman Jr., Leslie Jacobus, and Ernest De Baun.

On the cover: This 1908 photograph was taken by the Erie Railroad's official photographer. It appears through the courtesy of the New Jersey Midland Railroad Historical Society.

CONTENTS

ACKNOWLEDGMENTS

Truly, this book is the result of contributions by many. My appreciation is extended to the following for providing me with photographs and information:

Bob Armswood, Carol Banta and the United Presbyterian Church of Cedar Grove, Michelle Bogan, Andrew Boyajian, Isabel Bray and St. Catherine of Siena Church, Marian Taylor Canfield, Curtis Carlough and the New Jersey Midland Railroad Historical Society, the *Cedar Grove Observer*, Jack Chance, Alex Dannich, Dawn and Tom Earley, Michael Francaviglia of the Episcopal Diocese of Newark, Nancy Fraser, Karl Geffchen, Bob Goller, Michael Griffith and the Little Falls Public Library, Jan Harder and the Cedar Grove Community Church, Charles Heyer, Keith Honaman, the late Marge Izsa and the Cedar Grove Tax Assessor's Office, Fran Jacobs of the Friar Tuck Inn, Gary Kleinedler, Laura LaGrutta, Ed Lentz, Marty Liquori, John Maher and the Cedar Grove Recreation Department, the Newark Public Library, the New Jersey Historical Society, Rabbi Norman Patz and Temple Sholom of West Essex, Bob Pennisi of Railroad Avenue Enterprises, Nancy Pignatello, Peter Pignatello, Bill Schneider, Craig Sigler, Cesar Silva, Dixie Smith and St. Agnes' Episcopal Church, Passaic County Historian Ed Smyk, Janet Spong, Alvin Stauffer, Guy Vanderhoof, the *Verona-Cedar Grove Times*, Gordon Wickham, Verona Township Historian Bob Williams, Arthur Wynne Sr., and Steve Young.

Special thanks also go to the Cedar Grove Historical Society and in particular the Wednesday morning crew of Ren Chandler, Rita Norberg, Marcelle Beluschak, Ed Husni, and Barbara Young; the Cedar Grove Public Library for allowing me access to their historical archives; the folks at Photo Cullen for their expertise, patience, and timeliness with many of the photographs in this book; Dennis Sedaille and Tom Ries of the Division of Engineering of the Essex County Department of Public Works for sharing their marvelous collection of photographs of both Overbrook and county roads; Art Smith for discovering the carousel of slides of early Cedar Grove; Janet Vaast for providing me with photographs and information about her father, Arthur Wynne, the creator of the "word-cross" puzzle; and Hobie Van Deusen for his extensive collection of Cedar Grove postcards.

I also want to thank Chris Werndly, president of the Cedar Grove Historical Society, for previewing my slide programs that paralleled this book. His knowledge of the town is reflected in the pages of this book. Appreciation is also extended to my friends Ron Rice and George Sellmer. Ron not only provided many insightful suggestions regarding the text, but also led our winter expedition to find the headwaters of the Peckman River. George has continued to instruct me in the subtleties of our language, including the proper use of scientific terms. Lastly, gratitude goes to my wife, Jean, for accompanying me on our many rambles in search of the Cedar Grove of yesteryear.

Comments, corrections, or additional information is welcomed. The solution to the crossword puzzle can be obtained by sending a stamped, self-addressed envelope to the author at P.O. Box 111, Cedar Grove, New Jersey, 07009.

AUTHOR'S NOTES

In the summer of 1964, my wife, Jean, and I were searching for an apartment for ourselves and our infant son, David. The requirements were that it be in a northeastern New Jersey town served by a railroad and within 15 miles of New York City. On a map of the metropolitan area, an arc was drawn from midtown Manhattan extending 15 miles westward. On that arc was Cedar Grove, served by the Caldwell Branch of the Erie Lackawanna Railroad. That September, the three of us moved into the newly built Bradford Arms Apartments. I soon learned that commuting by rail from Cedar Grove was a time-consuming venture and that service was infrequent at best. Perhaps others realized this also, as patronage was light and passenger service on the Caldwell Branch was discontinued two years later. David and I rode the train on the last day of service, saved the schedule, and an interest in the history of railroads was born for both of us.

Several years later, I discovered Samuel Ward Boardman Jr.'s *From Then to Now - - - A History of Cedar Grove*. Much was revealed. The reason my commute on the Caldwell Branch was so time-consuming was that the circuitous route was selected only after the original and preferred route was abandoned before being completed. Financial problems were to blame. The original plan, requiring a tunnel under First Mountain, would have served both Verona and Caldwell but not Cedar Grove. Bradford Avenue—by then my road to the Upper Montclair train station—was so named because of the difficult journey by foot over First Mountain taken by Cedar Grove's first minister, Rev. Benjamin Bradford.

Jean returned to teaching in 1971 as a second-grade teacher at Ridge Road School. Several years later, Jean asked me to create a short slide program that highlighted the town's past. At the time, Cedar Grove history was part of the second-grade curriculum. Needing to augment the slides with some additional information, I became a member of the Cedar Grove Historical Society. At that time, Leslie Jacobus, the first president of the society, was compiling a history of the town for the bicentennial. The product, *Early Cedar Grove*, contained many photographs and nicely complemented Samuel Boardman's book. Information on the mills along the Peckman River, the early homes, the history of the Cedar Grove Post Office, and the personal anecdotes of residents provided me with material for Jean's slide program.

In the early 1980s, my interest in transportation had broadened to include the Morris Canal. I soon found that postcards were a marvelous medium for obtaining early-20th-century views of both the canal and towns such as Montclair. However, finding a Cedar Grove postcard was a rare event. Over the next 15 years, hundreds of trays of New Jersey cards were rummaged through, but only a few Cedar Grove cards surfaced. The postcards that I had collected were put to good use, however, in creating slide programs on the Morris Canal and Montclair.

In 1994, after more than two decades of teaching mathematics and computer science, I retired from Millburn High School. An abundance of time enabled me to turn my slide program on Montclair into the book *Montclair: A Postcard Guide to Its Past*, published by Arcadia in the summer of 1998. The book produced some unexpected results. A former resident of Montclair

became aware of my interest in local postcards and offered me his collection of approximately 70 Cedar Grove cards. A member of the Cedar Grove Historical Society had found a carousel of slides of early Cedar Grove at a flea market and also offered them to me. I accepted both offers. At that point, I realized there was enough pictorial material for a book on Cedar Grove. Still, many details behind the newly acquired images remained unknown.

The missing elements were provided by a voluminous collection of handwritten notes belonging to the Cedar Grove Historical Society and stored for many years at a local bank before being retrieved in late 1998. They were apparently given to Leslie Jacobus in the 1970s, who then stored them in the Cedar Grove Savings Bank where he was then a director. The notes had been written by Ernest De Baun, who lived most of his life in Cedar Grove on the east side of Pompton Avenue near today's Cinema 23. After leaving Cedar Grove in the early 1960s, Ernest resided at the Ward Homestead in Maplewood. Ernest himself wrote of how he began to record Cedar Grove's history. Ernest's description follows:

> What was a great and wonderful surprise it was to me around Thursday morning, November 16, 1967, when my name was called. I went to the desk as there was a phone call from Leslie Jacobus of Cedar Grove. We talked for a time and I was told a Cedar Grove Historical Society was going to be organized and that Leslie was coming over to see me that afternoon around 2 o'clock. I said I would be at the door to meet him. When Leslie came Arthur Taylor was with him. Leslie told me that he had been talking to the librarian at the Cedar Grove Library. She had told him about my interest in history and a conversation I had with her in 1960. So Leslie, Arthur and I had a grand old time for over two hours. I read them some of the articles I had written and Leslie said it sounded as though an editor had written them. He was to see me again December 7th. He told me that when there is a meeting he is coming to get me and bring me there. Now I am writing more history as more comes back to me. I am kept busy trying to get this accomplished. It would be so nice in many ways.

And it was nice in many ways. Ernest wrote his notes with painstaking care. He then rewrote them and polished the rewrites when necessary. His notes were detailed. They covered the evolution of the roads that crisscross today's Cedar Grove. They traced the history of the fire department, early homes and businesses, schools, general stores, the Public Hall, and many other aspects of the town's past. Ernest was born in 1898. He was an eyewitness to the transition of Cedar Grove from a farming community to a suburb. I am indebted to him for the many years he spent recording the history of our hometown.

One

THE PECKMAN RIVER AND ITS MILLS

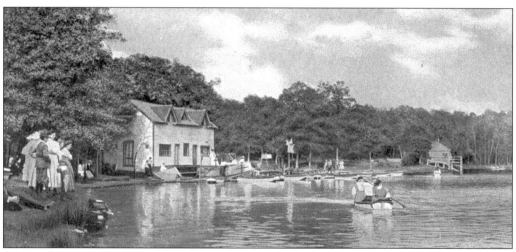

Originating near the crest of First Mountain, the Peckman River twists through the towns of West Orange, Verona, Cedar Grove, Little Falls, and West Paterson before emptying into the Passaic River. Its name is probably derived from the Native American word *pecamin*, meaning cranberry, which grew along the banks of the river. Beginning as two separate trickles in Eagle Rock Reservation and Crystal Lake, the Peckman becomes a single stream just west of Prospect Avenue in West Orange. This *c.* 1910 postcard shows Crystal Lake Amusement Park. Recreational activities at the park included boating, fishing, carousel rides, horseshoes, and winter skating. Because the lake was fed by a spring, swimming was enjoyed in a nearby pool, where the water was considerably warmer. It was often a destination for end-of-year school trips, including those from Pompton Avenue School in Cedar Grove; magicians and musicians frequently performed at such outings. Closed in the 1950s, the area is being developed today for town houses and will include an amphitheater, gazebos, and a walkway around the lake.

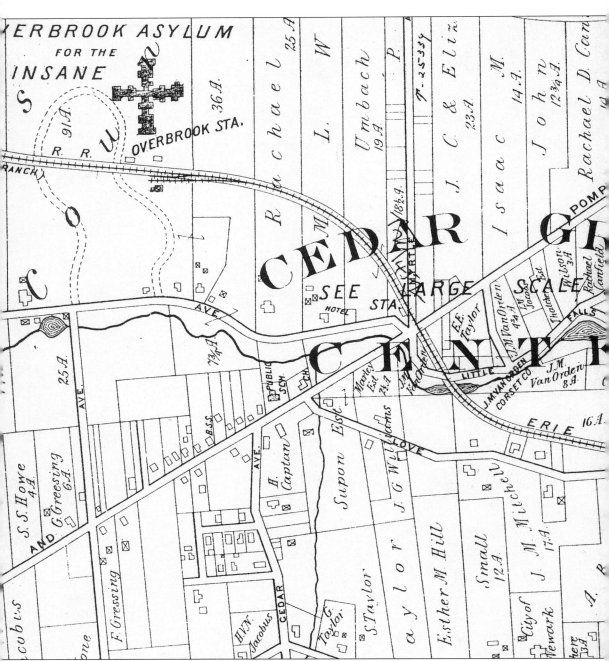

Upon reaching the valley between First and Second Mountains, the Peckman River essentially follows a northward course to the Passaic River. After passing through Verona, the river enters Cedar Grove at Ozone Avenue. A short distance downstream, at the corner of Grove and West Bradford Avenues, the Peckman fed a small pond as shown at the left on this 1906 map. The pond, known locally as Banker's Pond, supplied ice for Overbrook in the early 1900s; today it is the site of a baseball field. Slightly south of the Newark and Pompton Turnpike, today's Route 23, the river's flow is augmented by Taylor's Brook.

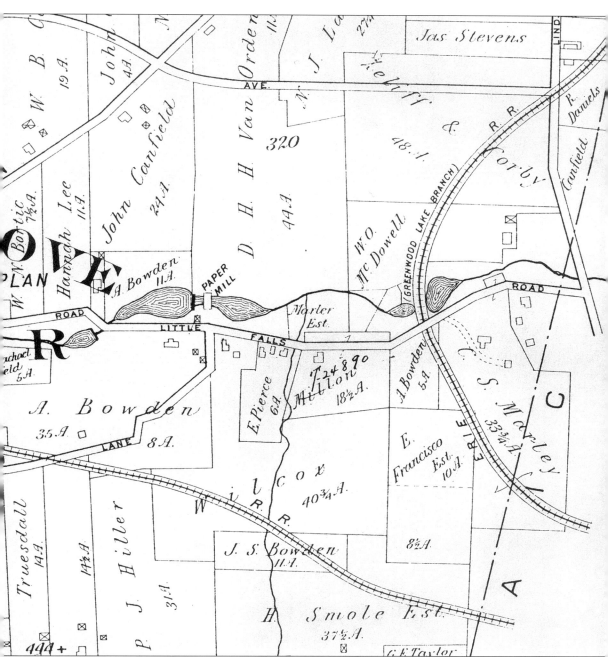

North of the turnpike, a series of millponds provided the waterpower for turning the machinery in Cedar Grove's mills. Heading downstream, these mills were the J. M. Van Orden Corset Company near the Caldwell Branch of the Erie Railroad; a snuff mill east of the intersection of Little Falls and Bortic Road; a paper mill, although the mill was more often used to process cotton, near the intersection of Love Lane (Bowden Road today) and Little Falls Road; and a mill for hub turning and sawing lumber, just north of the Greenwood Lake Branch of the Erie Railroad.

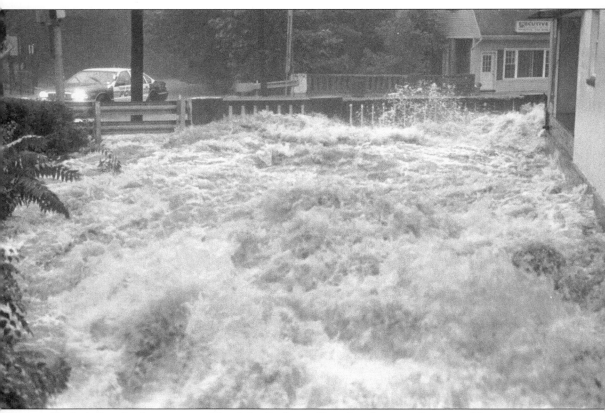

Taylor's Brook, the most notable of the Peckman River's tributaries, begins in Verona near the crest of First Mountain. It flows west to Pompton Avenue and then north to Ridge Road. After paralleling Ridge Road, it turns west near Cedar Street and runs in a concrete channel past the library. This scene of the brook at its intersection with Pompton Avenue was captured by Cedar Grove resident Alex Dannich near the height of Hurricane Floyd's rage in September 1999. The foot of rain in two days was dangerous and disruptive: some residents had to be evacuated, Ridge Road partially collapsed near Cedar Street, basements were flooded with up to 4 feet of water, telephone service was interrupted, and schools were closed. It was one of the worst storms of the century.

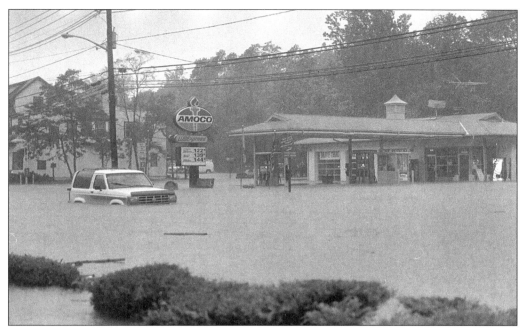

Alex Dannich also took this photograph during Hurricane Floyd's visit. The Pompton Avenue location is just downstream from where the Peckman River's flow is increased by the water from Taylor's Brook. Floyd not only briefly closed Pompton Avenue but also was responsible for shutting down Route 46 eastbound traffic for two weeks.

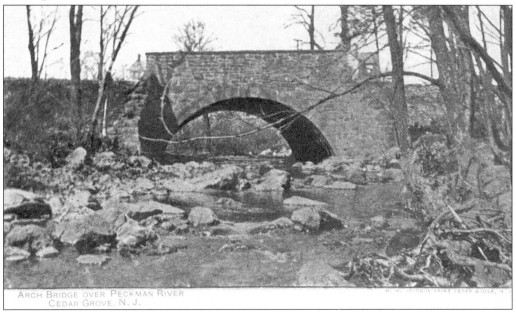

ARCH BRIDGE OVER PECKMAN RIVER
CEDAR GROVE, N. J.

This postcard of the stone arch bridge over the Peckman River is from the early 1900s. Constructed in 1880, the bridge carried the Newark and Pompton Turnpike over the river. In 1894, the road was sold to the county, and tolls were abolished. Herbert H. Jacobus, whose home and printing business were on Cedar Street, published this postcard and many others.

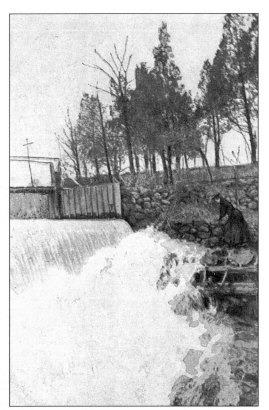

Van Orden's dam, the first dam in Cedar Grove going downstream on the Peckman River, was located just north of the railroad. While earlier mills at this location relied on falling water to move their machinery, the Van Orden Corset Company factory was powered by a steam boiler that received water piped from the pond. The factory produced steel stays for corsets and had offices in Newark and New York City.

The Van Orden Corset Company factory was located between the river and Little Falls Road. Gutted by fire in 1925, the building was bought two decades later by Tom Wilberton, the founder of Cedar Grove's Industrial Village. Wilberton's intention of restoring it did not materialize, and the building was razed in the 1950s. A concrete wall remains along the west bank of the river.

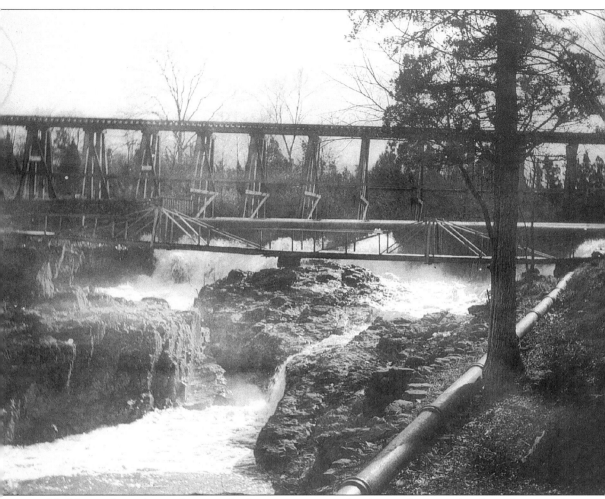

Visible on the right in this view looking upstream to the dam is the pipe that brought water from the pond to the Van Orden Corset Company factory's steam boiler. Devil's Hole, in the foreground at the left, is today a home for trout, which were reintroduced to the stream by Friends of the Peckman River. In the center is a wooden footbridge connecting the east and west banks of the river. Just above the footbridge is the dam with water cascading over it. Unseen beyond the dam is the impounded water, Essex Pond, a popular ice-skating spot near the center of town. At the top is the wooden trestle for the Caldwell Branch of the Erie Railroad. Constructed c. 1890, the wooden trestle was later replaced by a metal one. Although trains no longer rumble over the trestle, the river still flows over the remains of the dam that once stored its waters.

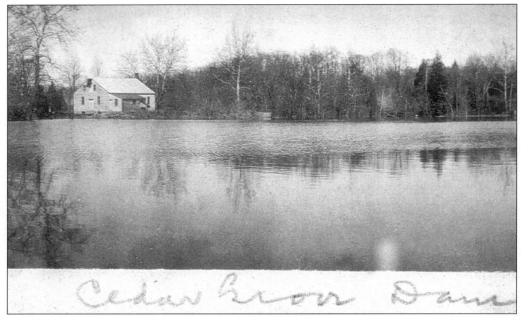

Cedar Grove Dam

Downstream, the millpond in the foreground was located along Little Falls Road near its intersection with Bortic Road. The unseen Cedar Grove Dam was adjacent to the mill. Over the years, the mill had various functions: weaving woolen blankets for the Union army during the Civil War, bark grinding, and snuff making.

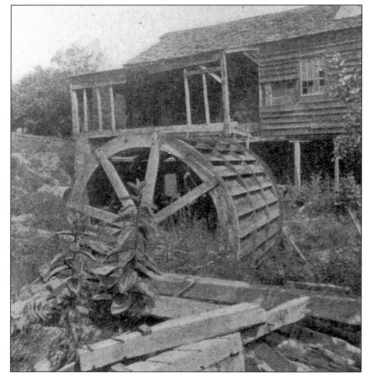

In the 1880s, the mill was known locally as "Steve Allen's Bark Mill." The bark, after being ground into powder, was used to tan leather. Newark, a leading manufacturing center for shoes, harnesses, and leather goods in general, was presumably a major destination for the mill's output. The waterwheel, a breast wheel, received water approximately "breast high" from the pipe on its left.

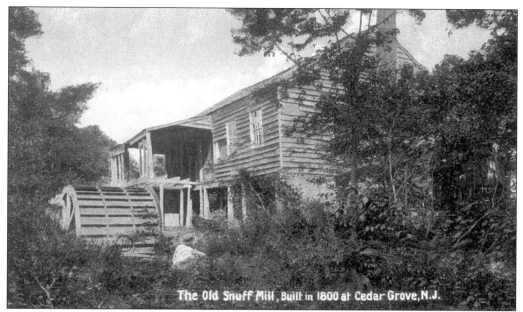

Vernon Royle, a prominent Paterson inventor and photographer, took this image of "the Old Snuff Mill" *c.* 1893. Reputedly, snuff's medicinal powers included relieving colds, curing headaches, and eliminating nasal congestion. The latter may have been true; according to local legend, it was not possible to walk past the mill without sneezing.

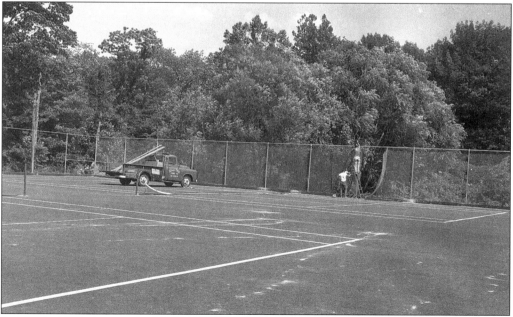

In March 1927, despite the efforts of firemen pumping water from the adjacent millpond, the mill was destroyed by fire. In 1940, the town purchased the property for future recreational use. In the 1950s, the pond was filled with soil from the rear of the Community Church, and tennis courts were soon constructed. The fence underwent repair in 1962.

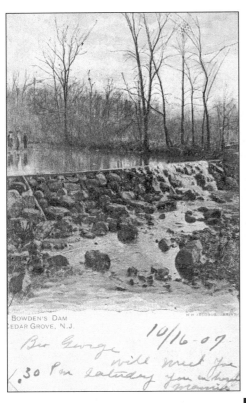

BOWDEN'S DAM
CEDAR GROVE, N.J.

In the late 1700s, Richard and Thomas VanRiper built a turning mill off Little Falls Road opposite today's Bowden Road. A half century later, John Bowden, originally from England, purchased the mill. Bowden enlarged it and introduced machinery to make cotton batting. The dam, which impounded water in a secondary millpond, was located just south of Little Falls Road. By the late 1940s, both the mill and dam were gone.

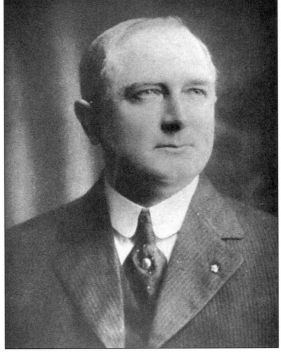

In the late 1850s, John Bowden died, and the operation of the mill passed into the hands of his sons, Anthony and William Bowden. John Bowden's grandsons, Lewis G. and William Bowden, ran the mill until the end of its operation. Lewis G. Bowden, seen on the right, became Cedar Grove's first mayor in 1908, serving for two decades. In 1938, Love Lane was renamed Bowden Road in honor of the family.

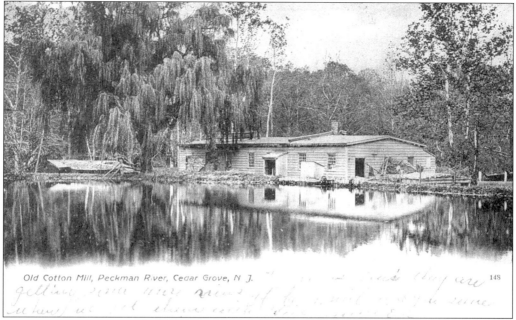

Old Cotton Mill, Peckman River, Cedar Grove, N. J.

Cedar Grove's first railroad arrived in 1873 and crossed Little Falls Road north of Bowden's mill. A station, used for both passengers and freight, was built just east of the road on land given by Anthony Bowden. Raw cotton was received there and transported to the mill by horse and wagon. It was then spun into yarn for blankets, batting, and mop heads.

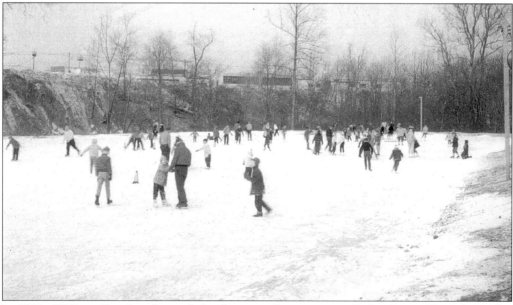

In 1951, William Bowden donated the former mill property to Cedar Grove Township. This winter scene from a decade later finds skaters enjoying themselves in the area formerly occupied by the primary millpond. The former mill area had a modern counterpart on the hillside—Tom Wilberton's Industrial Village.

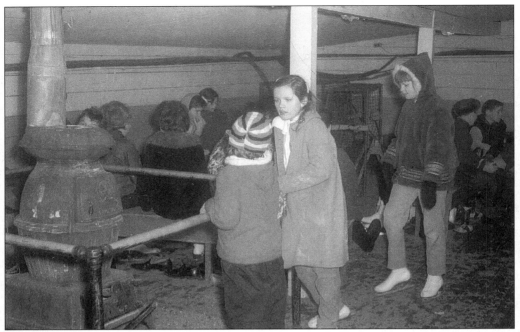

In the early 1960s, skaters found warmth and rest near a potbellied stove inside the Lion's Den at the southern end of the skating pond. The shelter—previously a chicken barn at the White Egg farm on Pompton Avenue near Ridge Road—burned to the ground in the 1970s and was replaced by the structure that is there today.

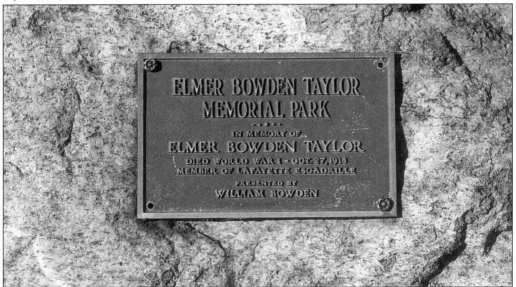

The Elmer Bowden Taylor Memorial Park was dedicated in the 1950s to the memory of William Bowden's nephew. Elmer Bowden Taylor was the son of Edwin E. Taylor (an early Cedar Grove postmaster) and Josephine Bowden (the daughter of Anthony Bowden). He died in World War I. The park includes the land now used for basketball courts, tennis courts, and recycling.

Although lacking the concentration of Hurricane Floyd, the storm that struck Cedar Grove in the summer of 1945 was even more destructive. Beginning on July 18 that year, the area was pummeled with ten consecutive days of rain, which changed the Peckman River from a quiet stream into a torrent. At Farro's gas station on Pompton Avenue, the pumps and underground gas tanks were carried away by the swirling waters. At the quarry off Little Falls Road, large deposits of sand were washed downstream.

One of the casualties of the storm was the stone arch railroad bridge over the river. It was simply swept away. The bridge, which is just west of Little Falls Road and is similar to the vehicular bridge that exists there today, was built c. 1872. After a week of rain, the fast-flowing river had eroded much of the earth foundation at the base of the arch. At some point, the weakened arch became unable to withstand the excessive pressure of water, rocks, and trees and was washed away along with much of the embankment. Eerily, the rails and attached ties remained suspended in midair over the Peckman River when this photograph was taken after the storm. The vanished arch was soon replaced by the metal bridge that is there today.

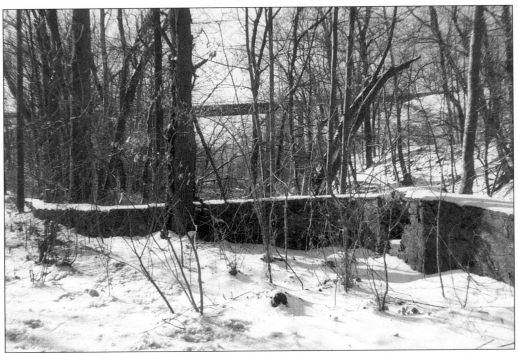

The last mill along the Peckman River in Cedar Grove was located downstream from the railroad bridge. Built in the early 1800s as a sawmill, it was later owned by Frank and Thomas Marley, who added machinery to make hubs and spokes for wagon wheels. When the Marley mill burned down in the 1890s, it was replaced by the structure whose walls still stand.

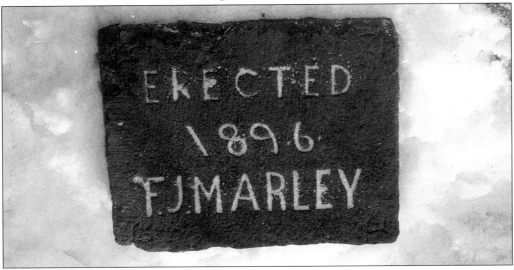

In addition to the mill's walls, an adjacent dam and the stone shown here have survived for more than a century. The stone, originally encased in a wall of the mill, contains the date and builder of the second mill. For many years, Frank J. Marley was a tax assessor in Little Falls, the next town that the Peckman River passes through before emptying into the Passaic River in West Paterson.

Two

TRANSPORTATION

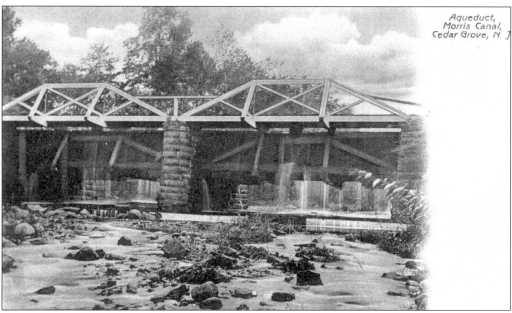

Aqueduct,
Morris Canal,
Cedar Grove, N J

The Morris Canal, a 102-mile-long ribbon of water between Phillipsburg and Jersey City, was completed in 1836. Primarily a carrier of coal and iron ore, it connected the anthracite fields of Pennsylvania with New Jersey's iron industry. Although the canal was considered an engineering marvel in its early years, commercial traffic had become insignificant by 1900. The Dismantling of the canal by the state began in 1924. The Morris Canal aqueduct shown on this postcard carried the canal over the Peckman River a short distance downstream from the Marley Mill. Before the railroad arrived in Cedar Grove, early settlers picked up their mail once a month after it arrived from Newark by canal boat. As it was also used to transport local products such as lumber, lime, and fertilizer, the canal was responsible for the early growth of the area. The aqueduct, located just west of Cedar Grove Road, was actually in Little Falls. Today, the canal bed is still discernible east of Cedar Grove Road.

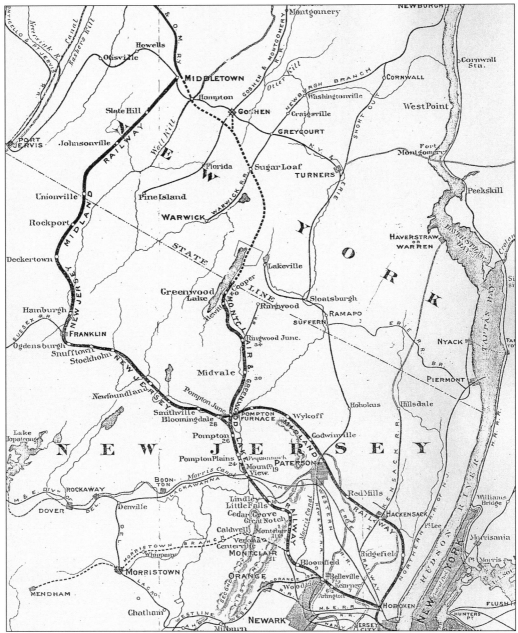

Northeastern New Jersey is shown on this *c.* 1877 railroad map. The railroad through Cedar Grove, the Montclair and Greenwood Lake Railway, was the successor to the Montclair Railway, which began operations in 1873. In turn, the Montclair and Greenwood Lake Railway later became the New York and Greenwood Lake Railway, which became a branch line of the Erie Railroad system in 1896. Cedar Grove, 18.5 miles from the railroad's eastern terminus in Jersey City, was more than an hour away. In 1874, the 7:33 a.m. train from Cedar Grove arrived in Jersey City at 8:40 a.m. Ferry service was available for those continuing to New York City.

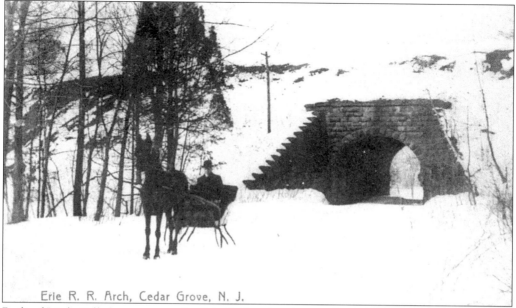

Erie R. R. Arch, Cedar Grove, N. J.

Built of Little Falls brownstone, the Erie Railroad arch is on Little Falls Road. A similar arch, just out of view on the left, allowed the Peckman River to flow under the railroad. Prior to 1900, the Cedar Grove passenger and freight station was to the right of the arch. Because of insufficient business, the stop was eliminated and the station was rolled away on a railroad flatcar.

Early on the Monday morning of the July 1945 storm, the mayor of Little Falls was warned of structural problems along the railroad in Montclair. The mayor, Clyde Smith, soon discovered a washout at Lindsley Road and a severely weakened bridge over the Peckman River. Waving a flashlight near the Little Falls station, he averted a tragedy by bringing the first eastbound train to a stop. The bridge was swept away a few days later.

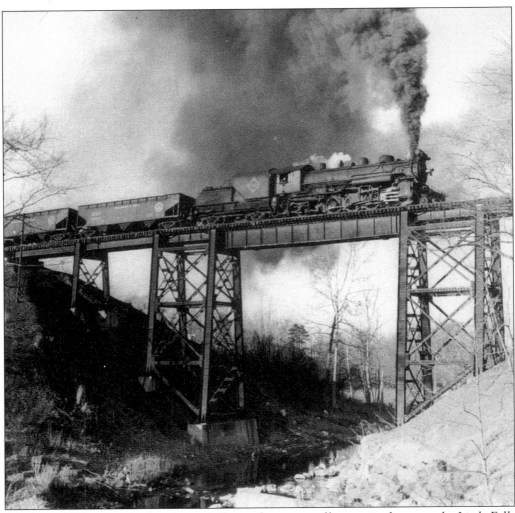

The missing bridge resulted in the immediate substitution of bus service between the Little Falls and Great Notch train stations. Bids for a metal replacement were soon received, and an $85,000 steel bridge was later installed. The interruption in service had little impact on Cedar Grove; its station stop on these rails had been abandoned decades before. This photograph was taken sometime after the installation of the new bridge and before the demise of steam power in the early 1950s. Headed east to Great Notch, the locomotive is trailed by a tender with the Erie diamond logo followed by Baltimore & Ohio hopper cars. Freight service to Cedar Grove exists today, and bimonthly shipments of resin are received by a company in the Industrial Village just east of this scene.

Takes Effect Monday, Aug. 3, 1891,
at 6 o'clock A. M.

For the government and informatio
of Employees and not for the public.

EAST BOUND TRAINS.								Distance from CALDWELL.	NAMES OF STATIONS AND SIDINGS.	Distance from JERSEY CITY.	WEST BOUND TRAINS.					
		FIRST CLASS.											FIRST CLASS.			
		12	10	8	6	4	2				1	3	5	7	9	11
		7.00 p.m.	1.30 p.m.	9.30 a.m.	8.30 a.m.		Ar. NEW YORK, 23d St. Dep		7.55 a.m	12.40 p.m.	3.25 p.m.	5.10 p.m.	6.10 p.m.
		6.52 "	1.17 "	9.22 "	8.15 "		NEW YORK, Chamber St.		6.00 "	12.50 "	3.37½ "	5.15 "	6.22½ "
		P.M. Ar. 7.15	P.M. Ar. 5.39	P.M. Ar. 4.50	P.M. Ar. 12.18	A.M. Ar. 8.33	A.M. Ar. 7.16	4.55Caldwell Junction....	16.89	A.M. 7.30	9.13	P.M. 1.51	P.M. 4 41	P.M. 6.17	P.M. 7.25
		s 7.09	s 5.33	s 4.24	s 12.12	s 8.27	s 7.10	2.34Overbrook	19.10	s 7.37	s 9.20	s 1.58	s 4 43	s 6.24	s 7.32
		s 7.05	s 5.29	s 4.20	s 12.08	s 8.23	s 7.06	1.19Verona........	20.25	s 7.41	s 9.24	s 2.02	s 4.52	s 6.28	s 7.36
		7.01	5.24	4.16	12.04	8.19	7.02Caldwell........	21.44	Ar. 7.44	Ar. 9.27	Ar. 2.05	Ar. 4.55	Ar. 6.31	Ar. 7.39
		P.M.	P.M.	P.M.	P.M.	A.M.	A.M.				A.M.	A.M.	P.M.	P.M.	P.M.	P.M.
		12	10	8	6	4	2				1	3	5	7	9	11

SPECIAL INSTRUCTIONS.

Employees will be governed by the Rules of the Transportation Department of the New York, Lake Erie & Western R.R. All Trains will run Daily, except Sunday.

East Bound Trains have right of track against trains of the same class running in the opposite direction.

W. W. WORTHINGTON,
General Manager.

On August 3, 1891, the Caldwell Railway Company began operations. Branching off the New York and Greenwood Lake Railway at a location known as Caldwell Junction, the Caldwell Railway made station stops at Overbrook, Verona, and Caldwell. In that year, both Cedar Grove and Verona were part of Caldwell. A station at Cedar Grove Centre was later built, resulting in the town having three stations in the late 1890s: Little Falls Road, Overbrook, and Pompton Avenue.

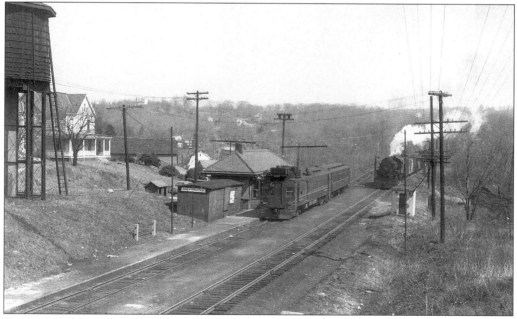

By 1949, Caldwell Junction had long since become Great Notch. A gas-electric rail motorcar from that year is on the left track, and a local freight train is on the right track. The water tower at the left was used to service steam locomotives. Diverging west of the station, both tracks go to Cedar Grove; the Caldwell Branch turns southwest, and the Greenwood Lake Railway turns northwest.

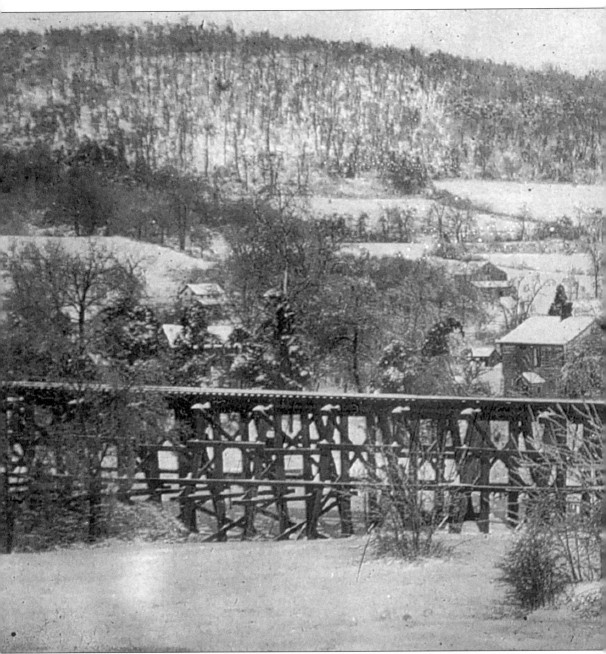

Two miles from Great Notch, east of Pompton Avenue, the Caldwell Branch of the Erie Railroad (the successor to the Caldwell Railway) crossed the Peckman River on a long wooden trestle. With Second Mountain dominating the background and the river flowing beneath the trestle, it is apparent why, centuries ago, the area was known as the "Pecamin Valley." Also apparent from the denuded hillside is how settlers in the valley ensured their survival and obtained sustenance. From the forest came timber for shelter and warmth; from the cleared fields came crops and nourishment.

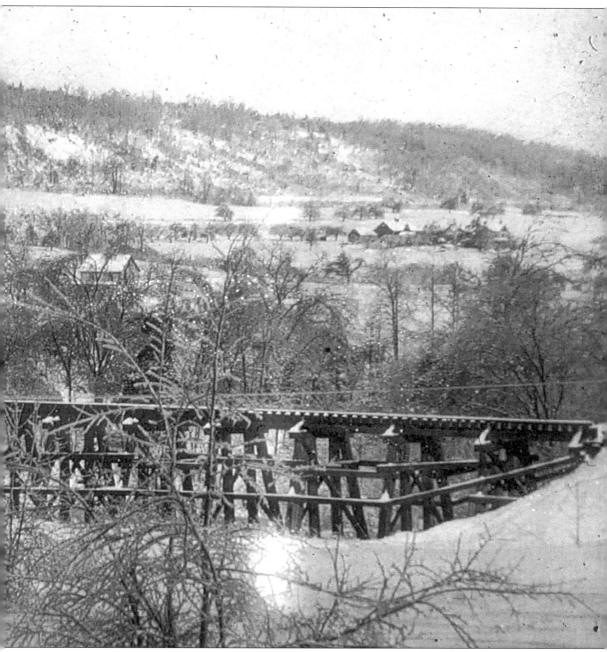

This winter scene is from the late 1890s. Slightly above the right center of the photograph is Cedar Grove's second post office. The building was located on Pompton Avenue in the area occupied today by La-Z-Boy Furniture. On the right, roughly halfway between the top of the trestle and the crest of Second Mountain, is a cluster of houses and barns. Located on Fairview Avenue near Pompton Avenue, one of the barns still exists today.

Erie R. R. Trestle
Cedar Grove, N. J.

In this early-1900s view, an Erie Railroad freight train rolls east on the trestle over the Peckman River. From the foreground to the background are Devil's Hole, the wooden footbridge, the falls created by the dam, and Van Orden's dam. The largest freight customer on the line was Overbrook, which required a constant supply of coal for both heating and electricity.

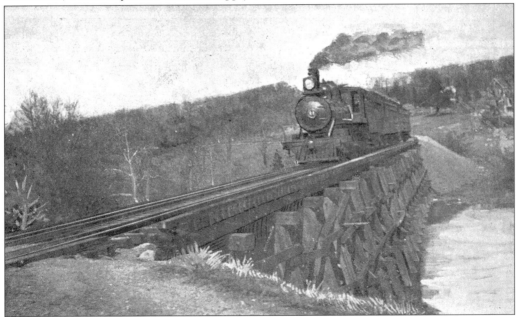

A few seconds after being photographed, this westbound passenger train arrived at the Cedar Grove Centre station. Essex Pond, created by the Van Orden dam is at the lower right. Service initially ran to Caldwell but was soon extended to Essex Fells. At Essex Fells, a turntable rotated the locomotive and tender to face east for their return trip.

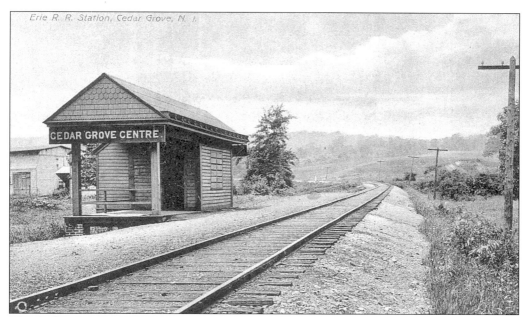

The Cedar Grove Centre station was on the west side of Pompton Avenue. When this scene was photographed, the area was still part of Verona; it became a separate township in 1908. In those years, a passenger could travel not only from Cedar Grove east to Jersey City but also west to Morristown over the tracks of the Morristown and Erie Railroad west of Essex Fells.

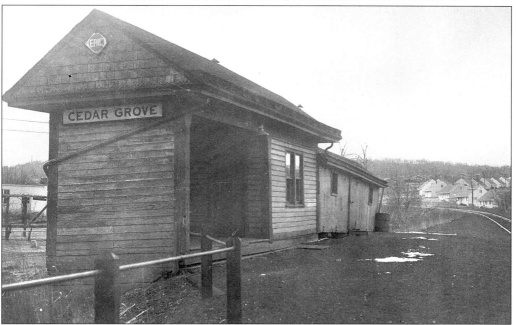

By 1954, the Cedar Grove station had felt the effects of lower Erie revenues and reduced maintenance. Automobiles, trucks, bus service, and tunnels had all served to drain both freight and passengers from the railroads and to empty them onto the highways. Cedar Grove had changed too; new houses and streets had transformed the rural town into a suburb.

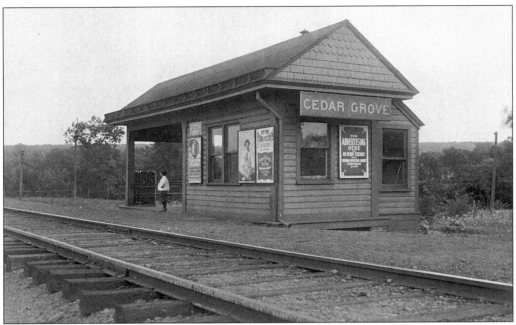

In 1909, the Erie Railroad commissioned a photographer to preserve the images of all its stations. Also in that year, Cedar Grove's status as a separate township was reflected in its station sign. Perhaps the boy is waiting for his father to return from a day in the city. Just behind the youngster is a sign for Wells Fargo Express, the freight company on the line.

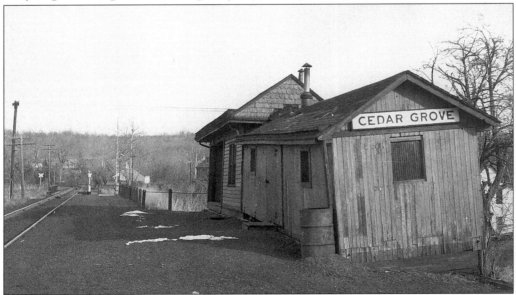

Again in 1954, this view looks east across Pompton Avenue. In the distance are the grade crossing signs where the railroad intersected Peckmantown Road. In the 1930s, a major dispute erupted between the Erie Railroad and the town concerning this location. The Erie Railroad wanted to close the road, and the town wanted crossing gates installed. The signs were a compromise.

EASTBOUND
MONDAY through FRIDAY, EXCEPT MAJOR HOLIDAYS —

TO NEW YORK	1400	1402	1404	1406	1408	1410	1414	1416	1418
	N.B.	N.B.	N.B.	N.B.	N.B.	N.B.	N.B.	N.B.	N.B.
	AM	AM	AM	AM	AM	AM	AM	AM	AM
Wanaque — Midvale Lv.	5.34	6.06	6.32	6.50	7.17	7.43
Haskell "	5.36	6.08	6.35	6.53	7.20	7.46
Pompton — Riverdale.... "	5.39	6.11	6.39	6.57	7.24	7.50
Pompton Plains "	5.42	6.14	6.43	7.00	7.28	7.53
Pequannock "	5.45	6.17	6.46	7.03	7.31	7.56
Wayne "	5.48	6.20	6.49	7.06	7.33	7.59
Mountain View (Erie Ave.) "	5.50	6.22	6.52	7.09			8.02
Singac "		6.25	6.56	7.13			8.05
Little Falls (Railroad Ave.) Ar.	5.54	6.27	6.58	7.15	7.39		8.07
Caldwell Branch { Essex Fells Lv.						7.20		7.44	
Caldwell "						7.24		7.48	
Verona "						7.27		7.51	
Cedar Grove "						7.30		7.54	
Great Notch Ar.						7.34			
Great Notch Lv.	5.58	6.31	7.02	7.19	7.34	7.44		8.12	8.35
Montclair Heights "		6.34	7.06	7.23	7.38		8.01	8.15	8.38
Mountain Ave. "		6.36	7.08	7.25	7.40		8.03	8.17	8.40
Upper Montclair "	6.02	6.38	7.10	7.27	7.42		8.05	8.19	8.42
Watchung Ave., Montclair "	6.04	6.40	7.12	7.29	7.44	7.51	8.07	8.21	8.44
Montclair (Erie Plaza).... "	6.06	6.42	7.14	7.32	7.46		8.09	8.23	8.46
Glen Ridge (Benson St.) .. "		6.44	7.16	7.35	7.49		8.12	8.25	8.48
Rowe Street "	6.09	6.47	7.19	7.38		7.56		8.28	8.51
Belwood Park "		6.49		7.40					
Forest Hill "	6.12	6.51	7.22	7.42					
North Newark "	6.14	6.53	7.24	7.44		8.00		8.32	8.55
West Arlington "	f 6.15	6.55	7.26	7.46	7.55			8.34	
Arlington "	6.17	6.57	7.28	7.48		8.05		8.36	8.58
Hoboken Ar.	6.30	7.10	7.42	8.02	8.09	8.18	8.31	8.49	9.11
FERRY New York, Barclay St. ... "	6.45	7.27	7.58		SEE		FERRY		NOTE
	AM	AM	AM	AM	AM	AM	AM	AM	AM

In 1960, as a means of reducing costs by eliminating duplicate facilities and services, the Erie and the Delaware, Lackawanna and Western Railroads merged. Several years before that, the eastern terminal for the Greenwood Lake line had been moved to the Lackawanna's Hoboken station. As shown in this April 1962 timetable, weekday eastbound service was down to two trains a day.

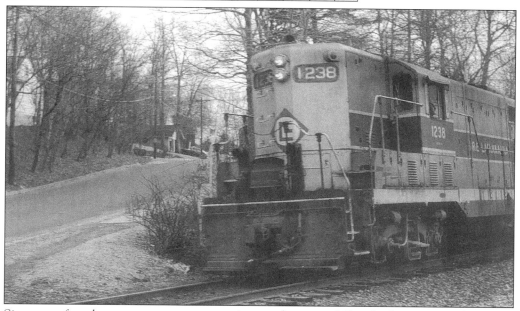

Six years after the merger, commuter service on the merged Erie Lackawanna Railroad was discontinued. Seventy-five years of commuter service on the Caldwell Branch ended with the last westbound train on September 30, 1966. Freight service, such as this eastbound train at the Bowden Road crossing, lingered for almost another decade.

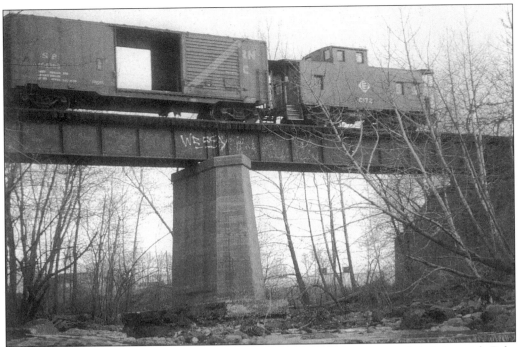

By the mid-1970s, the freight-only branch was incurring significant annual deficits, with Bahr Lumber and West Essex Building Supply in Verona among the few remaining customers. Shown is one of the infrequent freight trains running over the Peckman River bridge in those years. The Van Orden dam is at the lower right.

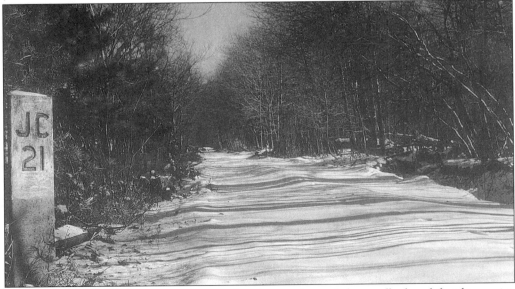

In the summer of 1975, a storm destroyed major sections of the roadbed and freight service abruptly ceased, never to be reinstated. Four years later, the rails were removed. Covered by a light snow in the winter of 1980, the right-of-way is shown in Caldwell, the town for which the railroad was named. The milepost indicates that the location is 21 miles from Jersey City.

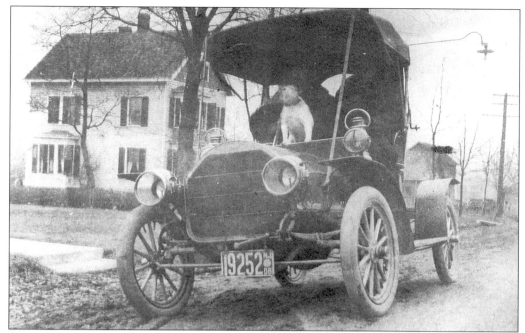

By the early 1900s, those new gasoline-powered vehicles were starting to appear on Cedar Grove's unpaved roads. In this photograph, Melancthon Jenkins's automobile is parked on the west side of Pompton Avenue near Union Street. The automobile may have been the town's first, as its license plate was issued in 1908—the same year that Cedar Grove became an independent municipality.

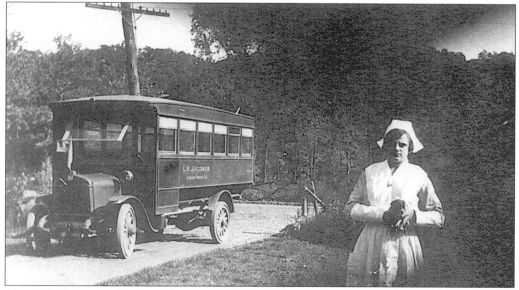

Owned by Linus W. Jacobus, this converted Day-Elder truck transported Cedar Grove students to Bloomfield High School. As part of the contract, Jacobus was required to provide bus service between Grove Avenue and the trolley line on Bloomfield Avenue in Verona. Top-heavy and with solid rubber tires, the bus also provided weekend service to Mountain View.

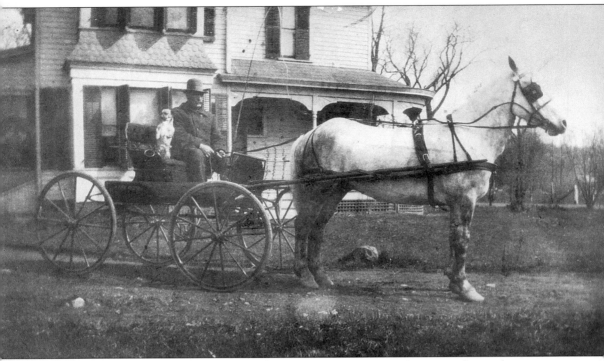

Thousands of years before the words railroad, automobile, or bus existed, simple carriages provided a means of transportation. Designed to be pulled by draft animals, they were a common sight until well into the 20th century. Photographed by the side of his home c. 1905, John C. Young shares the only seat in this buckboard with a friend. The Young family came to Cedar Grove from Newark in the 1890s and bought 28 acres of land west of Pompton Avenue and north of the new railroad. Initially farmed by Young and his three sons, the land was later developed, beginning in the 1920s. The south side of the house faces Young Avenue today.

Three

BUSINESSES

CASPAR J. DREIS

DEALER IN

Fine Wines, Liquors and Cigars,

JUNCTION OF

Pompton Turnpike and Ridge Road

CEDAR GROVE, N. J.

════

C. FEIGENSPAN'S P. O. N. AND EXPORT ON DRAUGHT.

PANNICK & KIEFER, EAGLE BREWING CO., EXPORT PILSNER, AND FRANCISKANER BEERS, ALE AND PORTER IN BOTTLES AND RANSLEY'S SODA WATER.

Conveniently located on the west side of the Newark and Pompton Turnpike at its intersection with Ridge Road, the tavern of Caspar J. Dreis was a family-run business serving German food. Feigenspan's brewery of Newark, once the largest in the country, supplied its Pride of Newark draught beer to the tavern. Established *c.* 1900, Dreis remained in business until 1920. On January 16 of that year, the 18th Amendment was ratified and the manufacturing and sale of alcohol became prohibited. Prohibition lasted almost 14 years, until the 21st Amendment was passed on December 5, 1933.

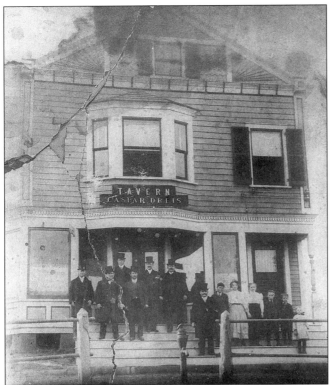

Apparently Dreis's Tavern was popular; the first public sidewalk in town ran between the railroad and the saloon. It was perhaps too popular—this picture may have been the victim of an errant bottle a century ago. The building, extant and next to the South End firehouse, served as the Dreis home as well as a place of business. Substantially altered, the porch is now enclosed and the steps no longer exist.

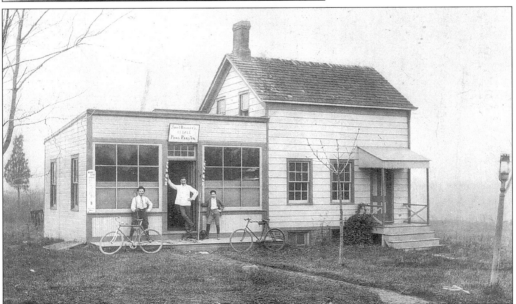

Sam Brower's 15 Ball Pool Parlor and Barbershop was on the west side of Pompton Avenue, north of Bradford Avenue. The barbershop, the first in town, was the site of a meeting at which the town's first volunteer fire brigade was organized on May 18, 1908. Brower, standing in the doorway, was a charter member. Cedar Grove was barely a month old that evening.

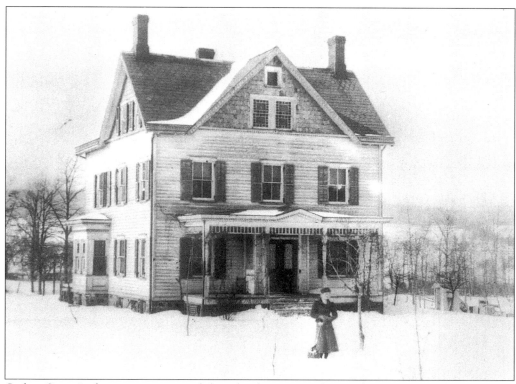

Cedar Grove's first restaurant and boardinghouse was begun by Jennie Taylor in 1902. Known as Taylor's Villa, patrons included Overbrook supervisors and Erie Railroad station agents. Jennie Taylor's daughter Helen Taylor is shown in this 1915 photograph. Five years after this picture was taken, Helen married David Carpenter, an Erie Railroad agent. Today, the building is Shook's Funeral Home.

Begun March 25, 1937, *The Observer* was the first newspaper devoted exclusively to Cedar Grove happenings. Originally staffed by six local high school students, Natalie Jacobus served as editor. The paper was printed at the Herbert H. Jacobus and Son print shop at 52 Cedar Street, owned by Roy Jacobus, who was Herbert's son and Natalie's father. Doug Robb, better known as "Scotty," helped in the production of the paper and later became a well-known major league baseball umpire. Publication ceased in 1948.

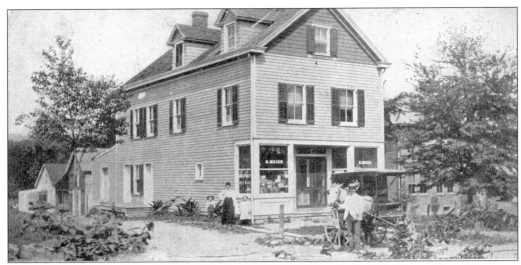

One of the town's first general stores was built in the late 1890s on the west side of Pompton Avenue opposite Cedar Street. Originally owned by John J. Vreeland, the building was sold to Gustav Meier in 1904. Gustav, originally from Baden, Germany, and his wife, Sophie Meier, had come to Cedar Grove from New York that year.

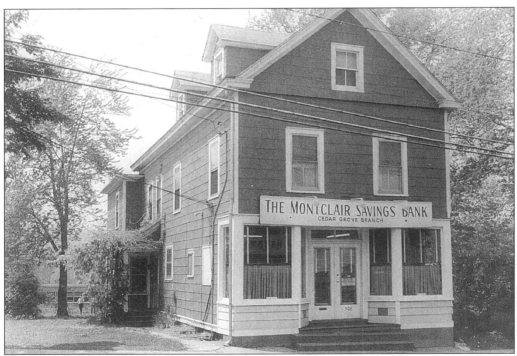

Gustav Meier operated the store until 1939. After housing the town's post office and several businesses, it became the home of the Cedar Grove branch of the Montclair Savings Bank in 1970. The building was razed the following year. In 1972, it was replaced by the building that is there today. Vreeland Lane suggests the corner's 19th-century heritage.

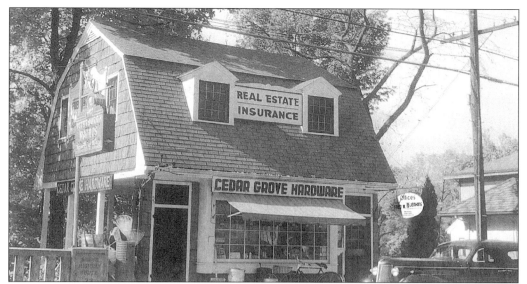

Owned by Thomas Kroy, Cedar Grove Hardware was on the first floor of this building, pictured in 1948. The second floor was used by Fred W. Jenkins for his real estate and insurance business; it also contained an office for the Cedar Grove Savings and Loan Association. The *Cedar Grove Observer*, which began publishing in 1999, occupies the building today.

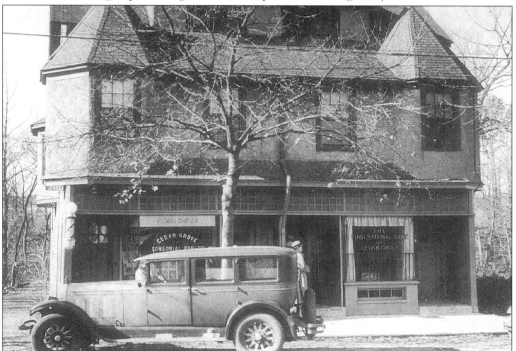

In 1927, Gustav Meier and others started the First National Bank of Cedar Grove. On November 7 of that year, the bank opened for business on the first floor of the Crawford Building. In the mid-1930s, the bank was the victim of a daytime holdup with the getaway car later abandoned on the corner of Pompton Avenue and Brunswick Road.

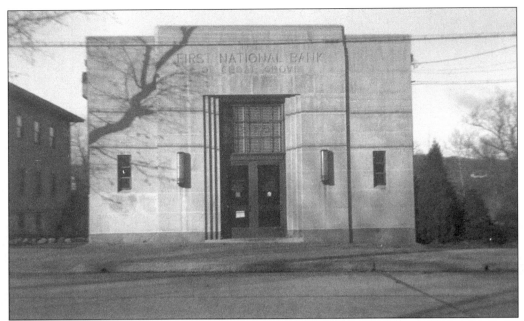

In 1938, the bank moved to a new building a short distance south of its original location. Cedar Grove residents Frank Del Fosse and Gus Meier Jr. were executives at the institution. After becoming a branch of the National Newark and Essex Bank in 1956, the building was altered and enlarged. It is now PNC Bank. The Public Hall is on the left in this photograph.

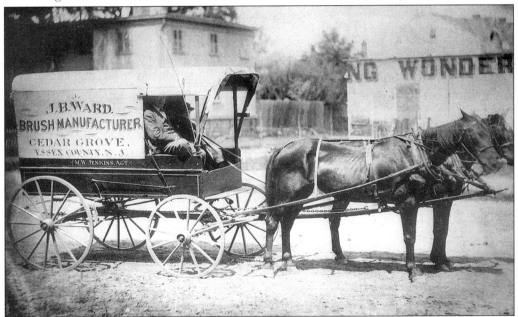

Born in 1854 in Montclair, Melancthon W. Jenkins became a sales agent at the age of 22 for brush manufacturer J.B. Ward. Jenkins's territory covered New Jersey, New York, and Connecticut. He and his wife, Mary (one of Ward's daughters), had six children, including one son named after him who became mayor of Cedar Grove in 1930.

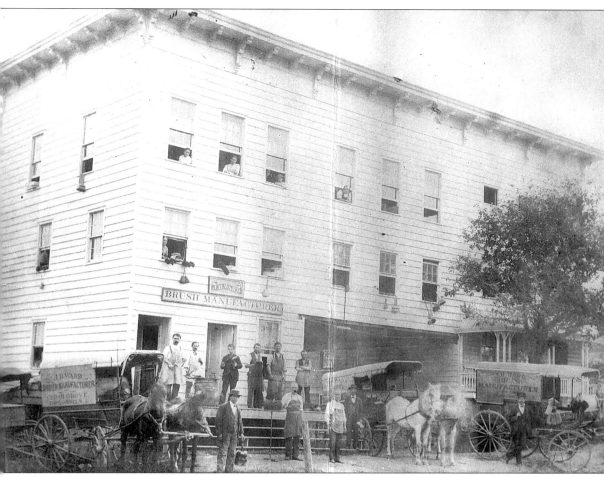

J.B. Ward's brush factory was located on the east side of Pompton Avenue south of Little Falls Road. Ward's building, constructed in 1854 and enlarged in 1872, was the largest one of its day in Cedar Grove and was a landmark on the Newark and Pompton Turnpike. Seemingly arrayed for a company photograph, salesman and mechanics are posed outside the building, while other employees and the company's household brushes are positioned at the open windows. Late on a Monday afternoon in April 1884, a pan containing a tarlike substance was being warmed when it suddenly exploded and began spewing flames. Fanned by a draft produced by the archway visible in this photograph, the flames soon engulfed the building and burned it to the ground. Only the chimney remained.

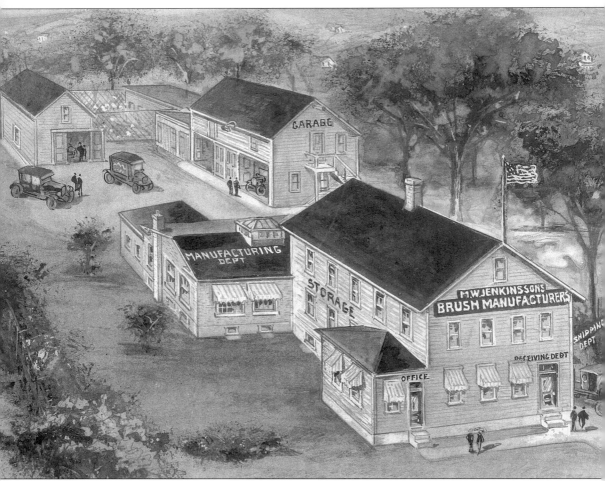

A few months after the fire, the August 23, 1884 issue of the *Montclair Times* reported that M. W. Jenkins would be carrying on the brush business in Cedar Grove. Jenkins initially set up his business under a tree near the site of the former Ward brush factory. Five years later, he moved his enterprise one-half mile south to the west side of the turnpike near today's Union Street. Again in 1900, fire destroyed the brush factory. Again it was rebuilt.

This drawing shows the Jenkins manufacturing complex as it was in the 1920s. While the horse barn at the upper left no longer exists and the manufacturing department acquired an extension in the 1940s, the view from Pompton Avenue today is remarkably similar to the artist's rendition of years ago. The business, Cedar Grove's oldest, at 444 Pompton Avenue, today makes customized brushes for industry.

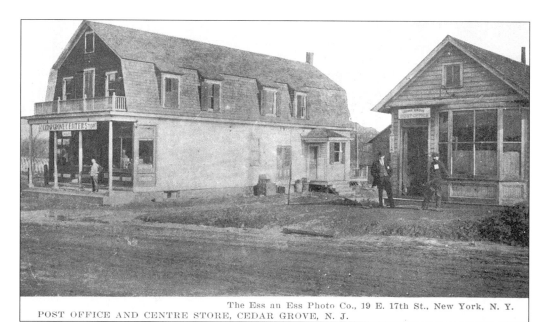

The Ess an Ess Photo Co., 19 E. 17th St., New York, N. Y.

POST OFFICE AND CENTRE STORE, CEDAR GROVE, N. J.

With the arrival of the Caldwell Railway in 1891, the local post office and some businesses moved near the new railroad. A general store was started by Edwin E. Taylor on the site of the former Ward factory. Perhaps ill-fated, it too was destroyed by fire. Its replacement, the Cedar Grove Center Store, is shown at the left in this postcard.

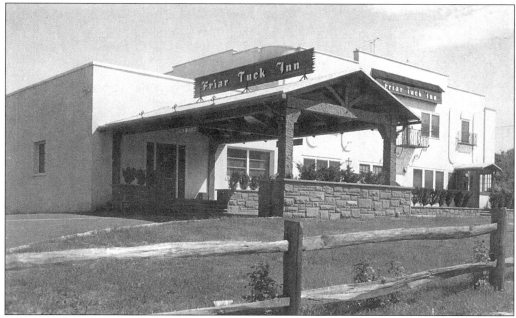

The Dutch House restaurant, located in a two-story building on Pompton Avenue near Little Falls Road, was built in 1938. In 1952, it was bought by Francis Jacobs and renamed the Friar Tuck Inn. The name came easily; the Robin Hood Inn in Clifton had been started by Jacobs's father, Sonny Jacobs. In this 1950s view, the newly added lobby is at the left.

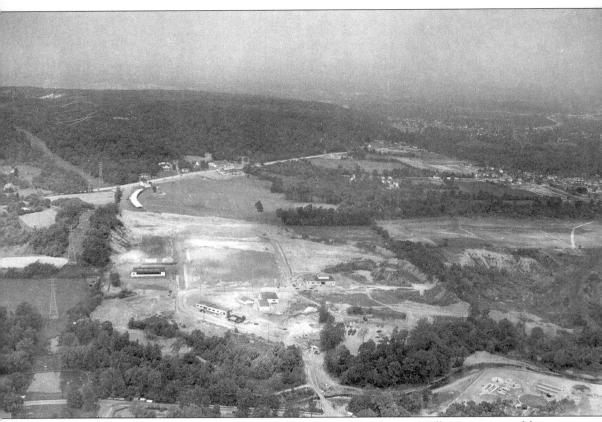

After serving in the U.S. Marine Corps in World War II, Thomas Wilberton returned home and bought the property formerly owned by the Van Orden Corset Company. Although there were plans to rehabilitate the old building and convert it into a tool and model shop, the plans stagnated. A few years later, in 1948, Wilberton bought the former Little Falls Sand and Gravel Company property between Pompton Avenue and Little Falls Road. Comprising 56 acres, the property was financed through the First National Bank of Cedar Grove and Frank Del Fosse. Located away from residential areas and with a railroad nearby, the site was well suited for light industry. Appropriately, it was named the Cedar Grove Industrial Village.

This aerial photograph was taken in 1948. Looking northwest, Pompton Avenue is the road in the center with Second Mountain behind it. Commerce Road, running off Pompton Avenue and snaking through the complex, is under construction.

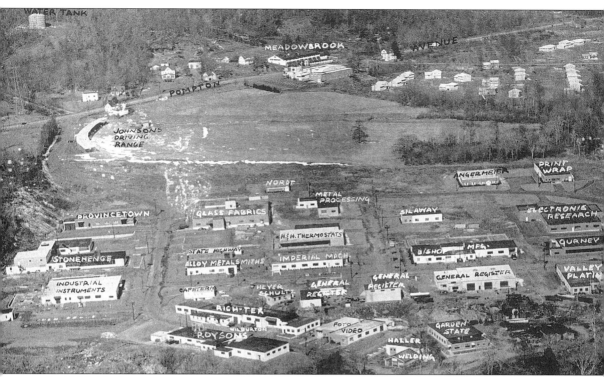

By 1958, 22 plants were in operation at the Industrial Village, including that of Rich-Tex, the first company to move into the complex. The diversified businesses produced a wide range of products, including medical equipment, printed fabrics, machinery and tools, and plumbing fixtures. Although the village has changed only slightly over the years, the streetscape along Pompton Avenue has undergone a radical transformation. Once at the western end of Commerce Road, Johnson's Driving Range no longer exists. Around the corner on Pompton Avenue, Clem's Bar and Grill was intentionally destroyed by the fire department in the early 1960s. After changing its focus from big bands to dinner theater and then to disco, the Meadowbrook closed its doors in the 1980s. Across the street, the unlabeled Four Towers was demolished in 1999. Stevens Avenue is shown at the upper right.

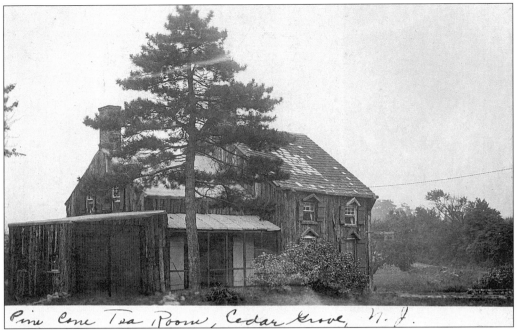

Pine Cone Tea Room, Cedar Grove, N. J.

The building near the corner of Pompton Avenue and today's Commerce Road had many occupants over the years. A residence in the early 1900s, it had become the home of the Pine Cone Tea Room by the 1920s. The tearoom was supposedly popular for its strong tea during the Prohibition years. By the 1930s, it was known as the Colonel's and in the 1940s, it became Clem's.

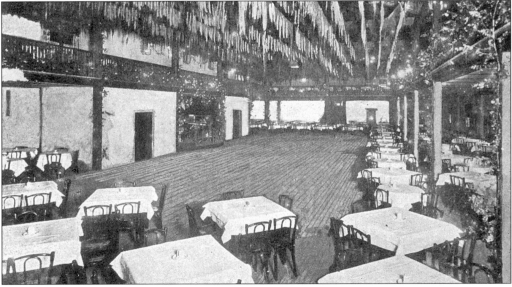

In the late 1920s, during Prohibition, one of the supper clubs on the Newark-Pompton Turnpike was the Castle Terrace. Whether the result of regulation or competition, the club went out of business and later reopened as the Royal Pavilion, a Chinese restaurant. The Royal Pavilion later closed also and remained empty until it was bought by Frank Dailey and his band.

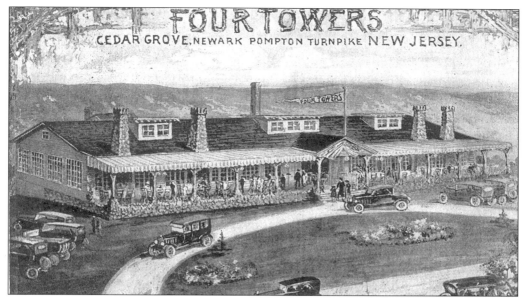

The Four Towers, according to its publicity, was "one of North Jersey's most famous restaurants and supper clubs." Also used for civic functions, the Cedar Grove North End Fire Company sponsored Saturday night dances there in 1942. Admission was 44¢, and defense stamps were given away as door prizes that year.

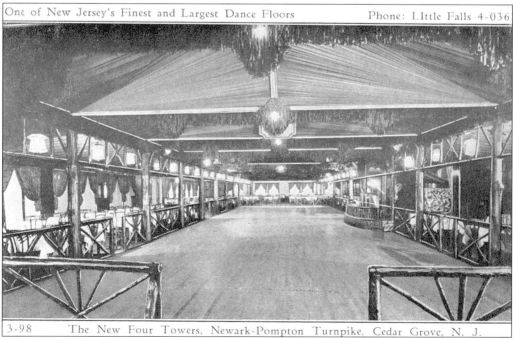

One of New Jersey's Finest and Largest Dance Floors Phone: LIttle Falls 4-036

3-98 The New Four Towers, Newark-Pompton Turnpike, Cedar Grove, N. J.

Around 1930, one of the bands playing at the Four Towers was the Meadowbrook Syncopators, led by Frank Dailey. One night, as the band was leaving the building after its performance, Dailey noticed a darkened restaurant, the Royal Pavilion, on the other side of the Newark-Pompton Turnpike. The band, tired of constant touring, decided to purchase the building.

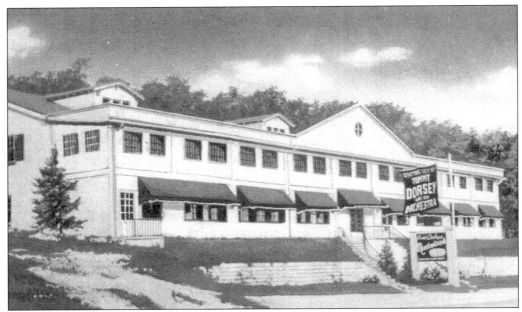

Soon after buying the restaurant, the new owners renamed it the Meadowbrook, for their band. In the mid-1930s, Frank Dailey bought out his partners and temporarily closed the roadhouse. After refurbishing the restaurant-ballroom and installing network radio lines, the building was ready for a gala reopening as Frank Dailey's Meadowbrook.

And open it did. The ballroom, while still reflecting its Castle Terrace heritage, was glamourous. Its 100- by 40-foot dance floor was roomy. Its capacity of 1,400 was spacious. After an initial engagement by Larry Clinton's orchestra, Frank Dailey's Meadowbrook soon became a showcase for America's big bands. It remained so into the late 1940s.

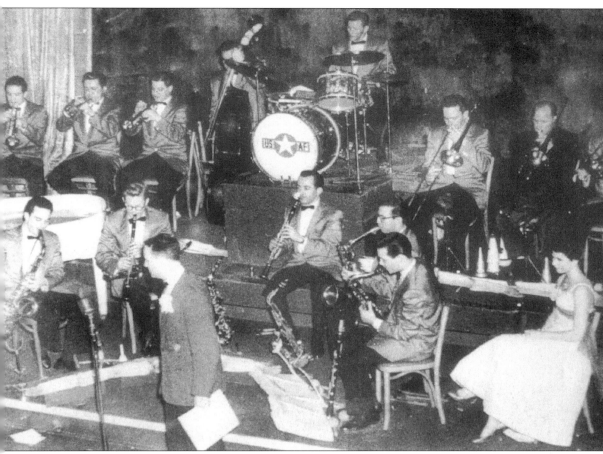

Throughout the late 1930s and 1940s, the Meadowbrook was host to nationally known bands and vocalists, such as Glenn Miller, the Dorseys, Guy Lombardo, Harry James, Ray Flanagan, Frank Sinatra, and Jo Stafford. In those years, the major radio networks often featured late-night big band concerts from nightclubs and hotels throughout the country. If you had been listening to the radio late Tuesday evening on March 12, 1940, you would have heard the announcer say, "Good evening and greetings ladies and gentlemen, the National Broadcasting Company takes pleasure in presenting the music of Glen Gray and his famous Casa Loma Orchestra playing for you this evening at Frank Dailey's Meadowbrook, Route 23, the Newark-Pompton Turnpike in Cedar Grove, New Jersey."

This photograph shows Ray Flanagan and his band at the Meadowbrook during World War II. It was during that conflict that a Japanese radio station broadcast the propaganda to our armed forces that the Meadowbrook had burned down. Such was its place then in the hearts and minds of America's youth.

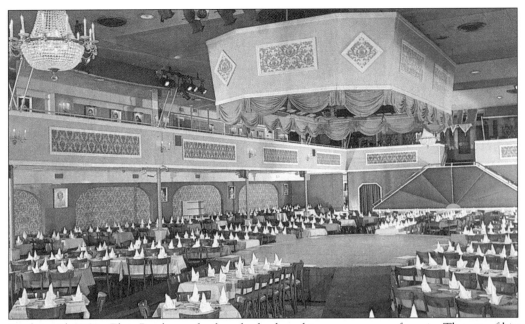

By the mid-1950s, Elvis Presley and others had ushered in a new genre of music. The era of big bands and swing music was over. After an involvement of a quarter of a century, Frank Dailey sold his nightclub. In 1959, after being closed for several years, the Meadowbrook reopened as the "world's first music theater restaurant." Dancing was available after the show.

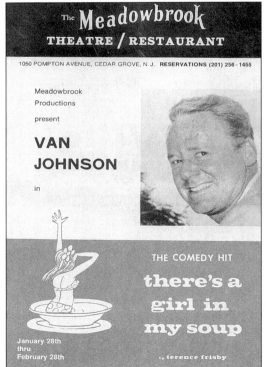

The Meadowbrook
THEATRE / RESTAURANT

1050 POMPTON AVENUE, CEDAR GROVE, N.J. RESERVATIONS (201) 256-1455

Meadowbrook
Productions

present

VAN
JOHNSON

in

THE COMEDY HIT

there's a
girl in
my soup

January 28th
thru
February 28th

by terence frisby

Broadway musical hits with Hollywood stars, television personalities, and nightclub comedians became the new offerings. By 1974, high salaries, labor problems, and gas shortages forced the Meadowbrook to close. The next ten years witnessed dinner-theater on a reduced schedule, rock bands, and disco music. The Meadowbrook closed in 1984.

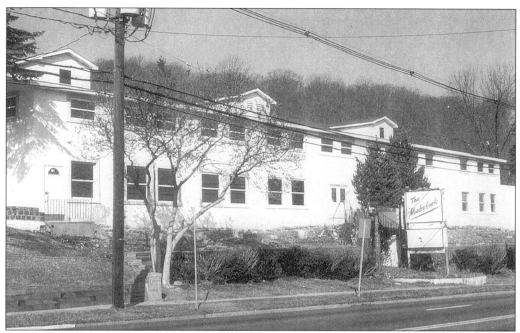

In 1994, the St. Kiril and Medotij Macedonian Orthodox Church bought the 10-acre property and its shuttered restaurant. While constructing its church next door, the congregation extensively renovated the exterior of the former Meadowbrook. The interior, refurbished but essentially unchanged, will again resound with music, played for weddings and receptions.

Taylor's Dairy Farm was bounded on the south by Cedar Street, on the north roughly by today's Sherman Avenue, extended almost to Eastwood Place south of Taylor's Brook, and to Bowden Road north of the brook. The farm was run by George Taylor and later by his sons, Earle and Robert Taylor. Looking northwest, this 1932 picture shows Ridge Road in the center.

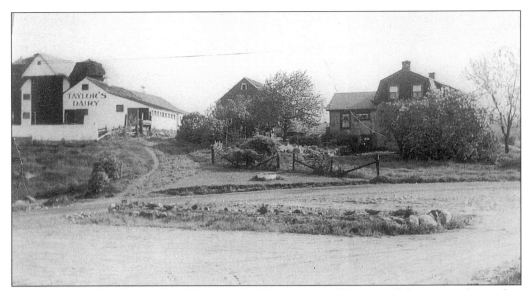

Consisting mostly of pastureland for cows, the farm contained barns, milk houses, and two silos. Crops, in particular corn for fodder, were raised in the area behind the barn. In the foreground is the parking area for the dairy store that sold milk and ice cream. At the right is the Taylor home, built in the 18th century by the Vreeland family.

By the 1950s, the dairy herd had been moved to Chester and much of the farm acreage had been sold to the town. Taylor's Ice Cream and Dairy Store remained a family operation until it was sold in 1965. In this 1976 photograph, a sandwich and ice-cream shop occupies the former dairy store. The complex was razed in the mid-1980s for new homes.

Four

ORGANIZATIONS

Congregational Church, Cedar Grove, N.J.

Organized in 1888 with 34 members as the Union Congregational Church, the congregation originally met in a schoolhouse on the site of today's Leonard R. Parks School. Three years later, on property previously owned by Mrs. Cornelius Supenor, a church was built on the west side of Pompton Avenue opposite Love Lane (Bowden Road today). Melancthon Jenkins and Robert Chesney were two of the founders of the church. At the left is the shed used to shelter the horses and carriages of worshippers during church services.

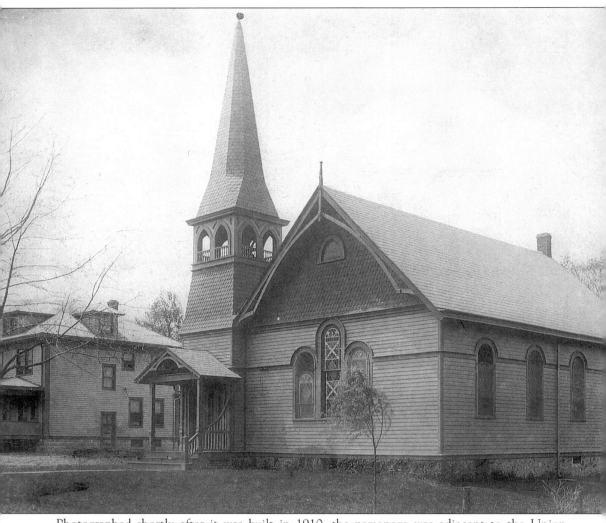

Photographed shortly after it was built in 1910, the parsonage was adjacent to the Union Congregational Church. Pastor Lewis and his family were the first to live in the residence. Attached to a long rope, the church's bell served as the town's fire alarm in the early 1900s.

In the 1920s, the old horse sheds were torn down and the church was enlarged to include a kitchen, Sunday school room, and auditorium. In that decade, Pompton Avenue, once a county road, had its designation changed from State Route 8 to State Route 23. Elm Drive and Church Street were constructed in those years.

Rev. Benjamin Bradford of Upper Montclair, the first minister of the Union Congregational Church, served from 1888 until 1907. In those pre-automobile years, serving his congregation was not easy. It required an arduous journey by foot over First Mountain and, in the evening, with a lantern to light the way. Sustenance for the return trip was always provided at the home of a church member. Bradford Avenue is named for him.

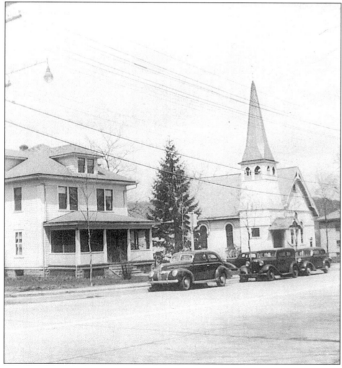

By the late 1930s, the automobile had made inroads. Pompton Avenue had been widened to four lanes and the Union Congregational Church had built a garage next to the manse. A decade later, the church changed its name to the Union Gospel Church of Cedar Grove and later to the Old First Church of Cedar Grove. In 1965, the congregation moved to a new home on Ridge Road opposite the reservoir. The church is now the Chapel on the Hill. In October 1970, the original church and parsonage were razed.

In the early 1900s, many Cedar Grove Episcopalians attended St. Agnes's in Little Falls. After it was noticed that they had walked to Sunday services, the church rented a truck to ease their journey. Regrettably, the trip was unpleasant, as the vehicle was used to transport fish during the week. The truck was later replaced by a public coach and then a bus.

In 1914, the Episcopalians in town organized St. David's Society. Over the next two years, they built (mostly with their own hands) a church on the east side of Pompton Avenue between Love Lane and the railroad. Arthur Wynne, a Cedar Grove resident and the inventor of the crossword puzzle, designed the church.

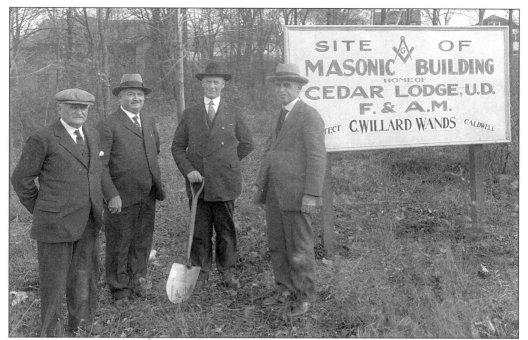

Cedar Lodge of the Free and Accepted Masons was organized in 1928. Groundbreaking for their new lodge at 589 Pompton Avenue occurred before the lodge had been granted a charter and was done "under dispensation." Lodge members later met on the second floor of their new building, now Hollens Hardware. Gustav Meier, senior warden, is second from the left.

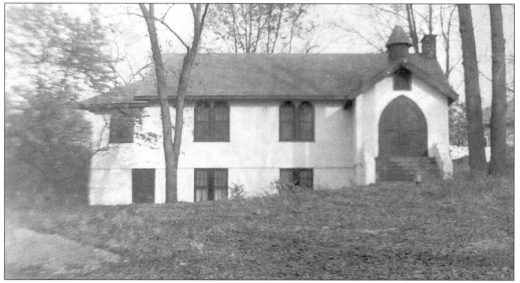

In 1936, as a result of declining membership, St. David's Episcopal Church was sold to Cedar Lodge. The building is shown after it was acquired by the Masons. In the late 1970s, the structure was demolished except for its rear wall, and a modern glass building was constructed. Embedded in the rear wall is the former cornerstone, which reads, "St. David's Guild Hall 1915."

In the late 1940s, some members of the former Union Congregational Church decided to form a new church, the Community Church of Cedar Grove. After holding worship services in private homes and the town council chambers, they bought the "Old Dusenberry House" on Bowden Road in November 1948. Three months later, worship services were held there.

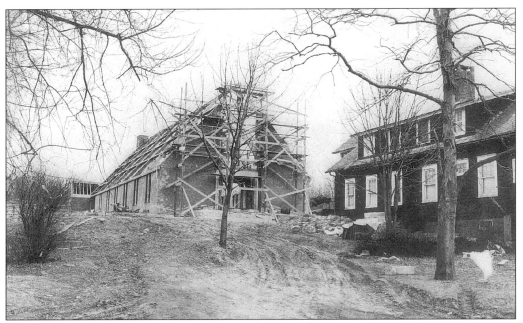

Sunday worship services were somewhat unorthodox—the front wall of the house was covered with a velvet drape and the choir marched in from the kitchen. In January 1951, a campaign to raise funds for a new church building resulted in 500 families being visited by 80 callers. The financial goals were surpassed and ground was broken that September.

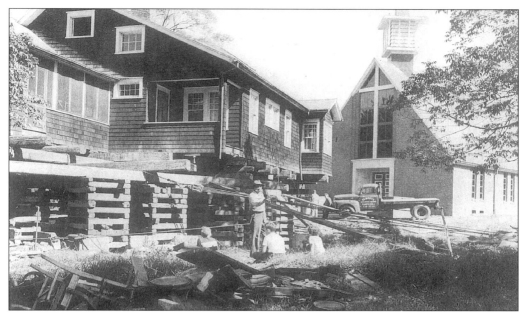

In the summer of 1952, at cost, the Wilberton Development Corporation excavated, graded, and built a foundation for the Dusenberry House on Sherman Avenue adjacent to the new Community Church of Cedar Grove. The land for the house was purchased through the generosity of the Davella Mills Foundation. After the house was moved, it was used by the church Sunday school.

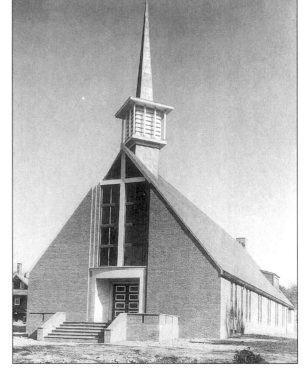

On November 2, 1952, the new Community Church of Cedar Grove was dedicated. The bell for the church came from the steeple of the former St. David's Episcopal Church and was a gift from the Masonic Lodge. In the spring of 1963, the Dusenberry House was destroyed by setting it on fire; part of its foundation is still visible in the earth on the north side of Frazier Hall.

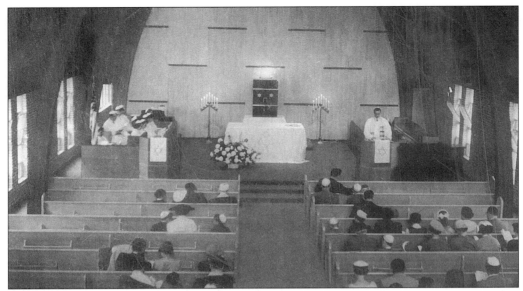

Thirty-five Jewish families from Cedar Grove met to form a religious community in November 1953. The following June, they conducted their first worship service in the Dusenberry House adjacent to the Community Church of Cedar Grove. As pictured, high holy day services were conducted in the fall of 1954 in the main sanctuary of the two-year-old church building.

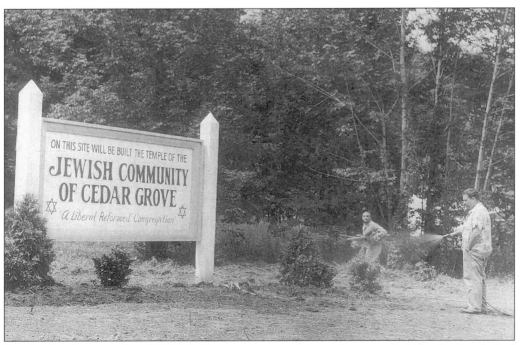

For the first five months of 1955, Friday evening worship services were held in the South End firehouse. The following year, with more than 100 families in its Reform congregation and an increasingly urgent need for a permanent home, 2.5 acres of land were purchased on the west side of Pompton Avenue between Cedar Grove Parkway and Mawal Drive.

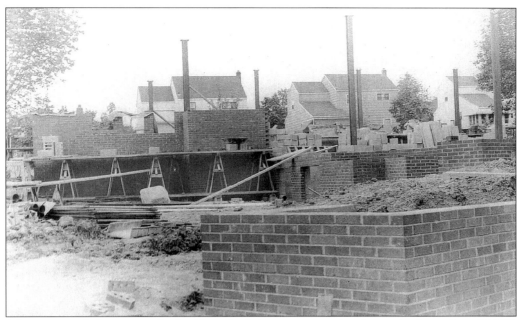

After a year of planning and a building fund drive, construction began in the spring of 1958. The new synagogue was intended to accommodate not only the 120 families in the congregation, but also to allow for growth. When completed, the split-level brick building contained a sanctuary, a school, and an assembly hall. This June 8, 1958 view looks toward Cedar Grove Parkway.

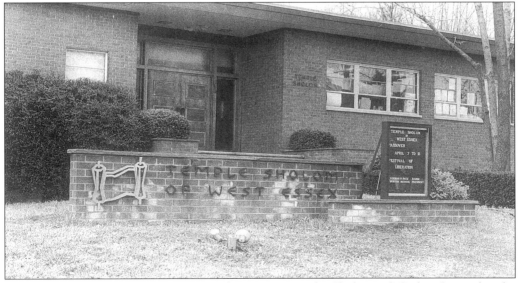

The completed synagogue was given the name Temple Sholom of Cedar Grove by the congregation. In 1968, in order to reflect the wider geographical area from which its members came, the name was changed to Temple Sholom of West Essex. Rabbi Norman R. Patz has been the leader of Temple Sholom since 1969.

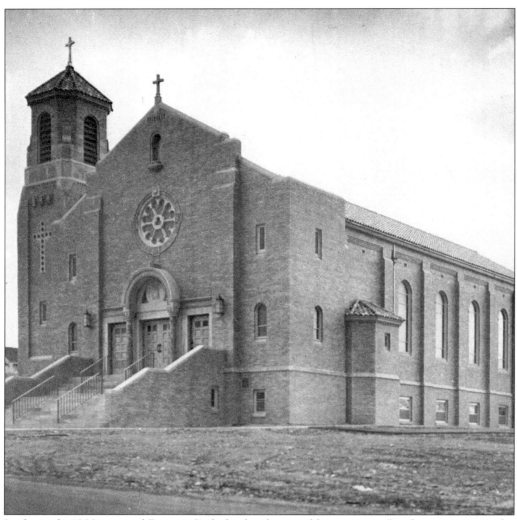

In the early 1900s, several Roman Catholic families would meet every Sunday morning on the corner of Pompton and Bradford Avenues before beginning their walk over First Mountain to attend church services at St. Cassian in Upper Montclair. By the mid-1920s, increased mobility allowed many of them to worship at the new Our Lady of the Lake Church in Verona. After World War II, primarily due to the efforts of the Bradshaws of Eastwood Place, a Cedar Grove parish was formed, which, in 1949, became a mission of Our Lady of the Lake Church. Sunday Mass was celebrated either at the Towers or at Frank Dailey's Meadowbrook in those years.

In the spring of 1950, John Bradshaw learned of the availability of the Grissing farm on the south side of Bradford Avenue, east of Pompton Avenue. Working through the Archdiocese of Newark, the land for a new church was soon purchased. The St. Catherine of Siena Church is shown after its completion in the fall of 1952. The church was dedicated on December 6 of that year, with Rev. Raymond J. Quinn as pastor.

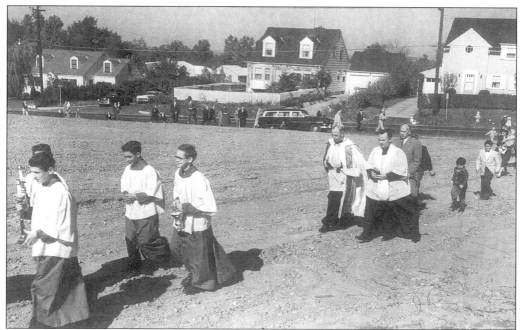

Groundbreaking for the St. Catherine of Siena School was celebrated in October 1957. The dignitaries in the procession are, from left to right, Rev. Raymond J. Quinn, pastor; Rev. Charles J. McDonnell, curate; and Robert A. Moran, architect. At that time, St. Catherine's children were attending Our Lady of the Lake School in Verona.

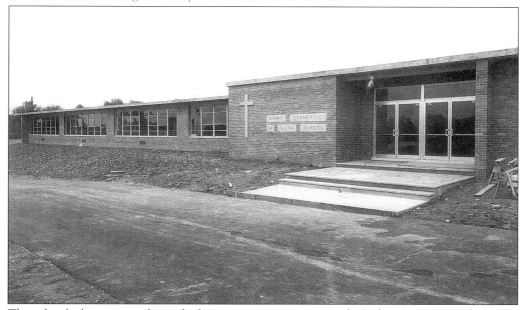

The school, shown near the end of its construction, contained 12 classrooms, special purpose rooms, and an auditorium with a seating capacity for 850 people. Staffed by Dominican Sisters and lay teachers, the school opened in September 1958 with 424 students in grades one through seven. An addition containing four classrooms and a library was completed in 1965.

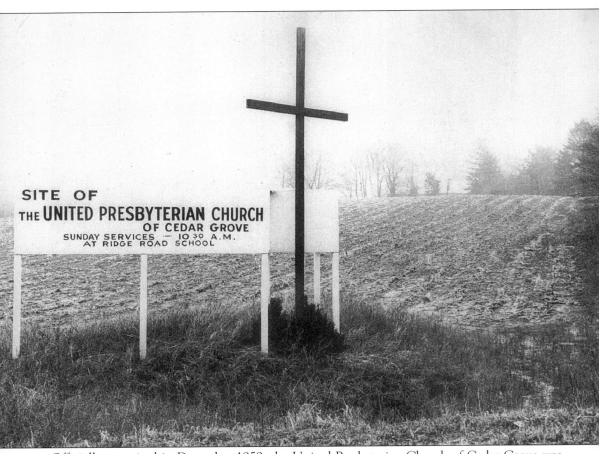

SITE OF
THE **UNITED PRESBYTERIAN CHURCH**
OF CEDAR GROVE
SUNDAY SERVICES — 10 30 A.M.
AT RIDGE ROAD SCHOOL

Officially organized in December 1959, the United Presbyterian Church of Cedar Grove was the first church organized by the Newark Presbytery in more than 25 years. The church's first pastor, Rev. Frederick R. Gibson, was installed on May 1, 1960. In those years, services were held at Ridge Road School, except in the summer, when Temple Sholom was used. Both buildings had only recently been constructed at that time.

One year after the church's organization, 3.7 acres of land were purchased—bordered by Pompton Avenue, Commerce Road, and the Industrial Village. The property was owned by Edith Morgan and was on the northern border of her farm, a Cedar Grove landmark.

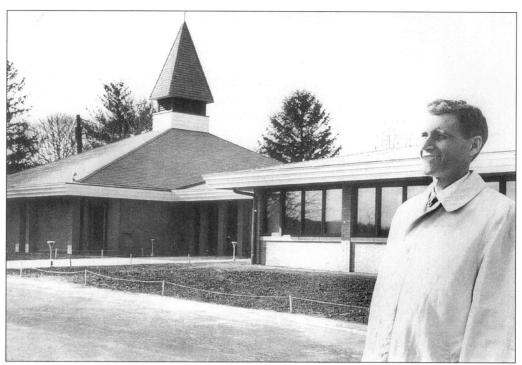

The first service on the newly acquired property was hold on Sunday, October 22, 1961, when more than 100 people gathered to worship without a physical church in the middle of a former cornfield. On November 21, 1965, the new home of the United Presbyterian Church of Cedar Grove was dedicated. Pictured outside the church is Pastor Gibson.

East of the church property is a graveyard, once called God's Acre Cemetery, that had been in use since the late 1600s. David Abeel, a New York merchant, lived from 1704 to 1776. The curled hair carved into his tombstone represents a popular style of wig in the 18th century, with the angel symbolizing the hope for the resurrection of the deceased. The last burial in the cemetery was in the 1930s.

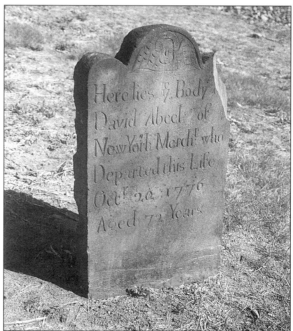

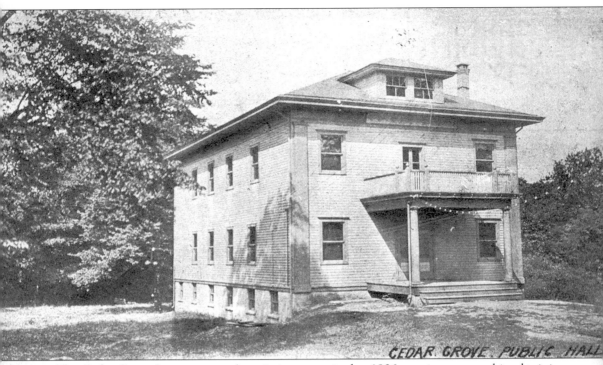

The Cedar Grove Improvement Association, organized c. 1906, was instrumental in obtaining public water, electricity, gas, and sidewalks for the town. Additionally, the association spearheaded a drive for the erection of a community building to be used for entertainment, lectures, and meetings. The building, the Public Hall, was completed in January 1912 and was located in today's PNC Bank parking lot. On the first floor, a large auditorium and stage was used for concerts, political rallies, plays, and dances (scorned by Pastor Lewis of the nearby Union Congregational Church). A gymnasium and meeting rooms were on the second floor. In the basement were a jail and an area for storing firefighting equipment.

After the municipal building was completed in 1929, the building became the recreation center and was used by both the town and the Works Progress Administration. Accidentally destroyed by fire on December 5, 1957, the remains of the structure was razed the following year.

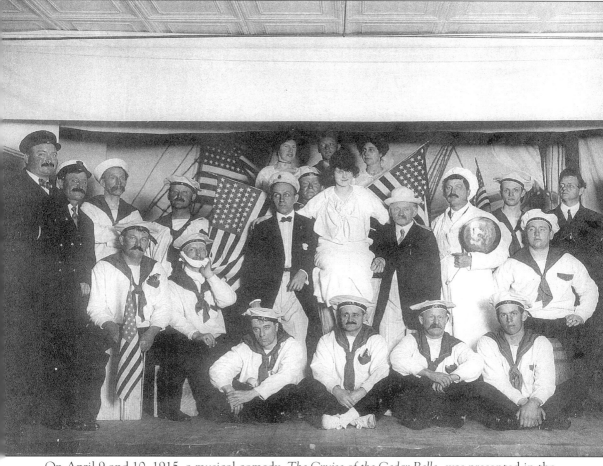

On April 9 and 10, 1915, a musical comedy, *The Cruise of the Cedar Belle*, was presented in the Public Hall. The production was set against the backdrop of a ship sailing down the Peckman River and eventually arriving on foreign shores. At Arthur Wynne's suggestion, the show was in the format of an operetta. Reflecting the federal government's initial position of neutrality between England and Germany in World War I, the pro-British and pro-German factions on the cruise got along quite harmoniously.

Pictured, from left to right are, the following: (first row, sitting) unidentified, Harry Adams, Warren Jacobus, and Albert Grissing; (second row) William Small, Samuel Boardman, William Bradshaw, Sadie Evans, ? Evans, Millard Jacobus, and unidentified; (third row) Gustav Meier, Jacob Grissing, Alexander Cowie, Fred Grissing, Edward J. Scheiber, and two unidentified persons; (fourth row) Ellen Cowie, ? Lynn, and Olive Ougheltree.

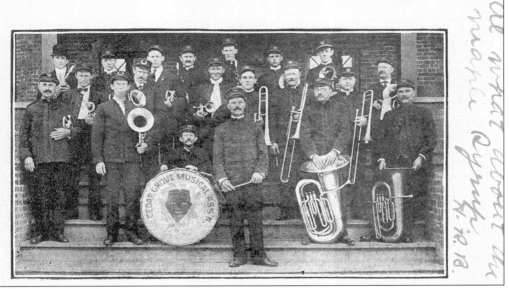

Organized in 1906, the Cedar Grove Musical Association's activities included giving summer concerts on the schoolhouse green and leading the procession for Sunday school picnics. The band, with Al Ingold as director, was photographed on the school's steps. The tuba player on the extreme right is John C. Young Sr. Behind him is Warren Jacobus.

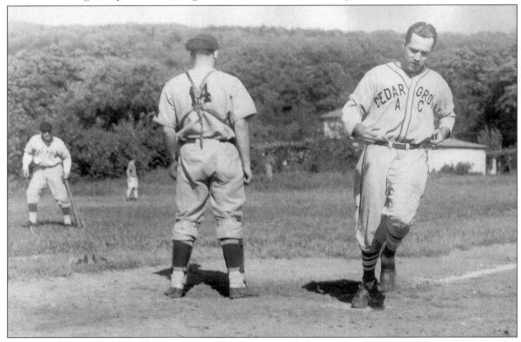

Frank Del Fosse, originally from Brooklyn, organized the Cedar Grove Athletic Club in the early 1930s. This photograph shows Ted Chandler arriving at home plate after hitting a home run. Called "the Home Run King" by *The Observer*, Chandler played left field in 1941, the last summer before he and other players left to serve in World War II.

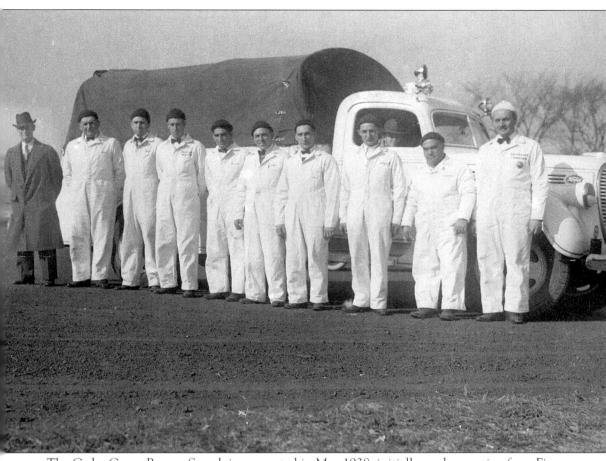

The Cedar Grove Rescue Squad, incorporated in May 1938, initially used an engine from Fire Company No. 1. The following February, the squad received its first rescue truck, a 1938 Ford, from Verner-Cadby of Verona. Bought without its cover, Minnie Baldwin—whose home was where the Chapel on the Hill now stands—was instrumental in raising money to obtain one. From 1938 until 1964, the rescue squad used the Center Fire Company facilities at the municipal building as its headquarters. Pictured in 1940 in their dress overalls, from left to right, are director Bill Crawford, Henry Schaffer, Lloyd Smith, Charles Winters, Louis Pignatello, George Sigler, Anthony Shilling, Henry Shilling, Bosco Ferranovia, and Wallace Crawford. The squad's own building was completed in 1965 on Pompton Avenue just north of the railroad. In 1983, the rescue and ambulance units merged to form the Cedar Grove Ambulance and Rescue Squad. A few years later, the Pompton Avenue structure was expanded with an addition containing three bays and a second story over the enlarged building.

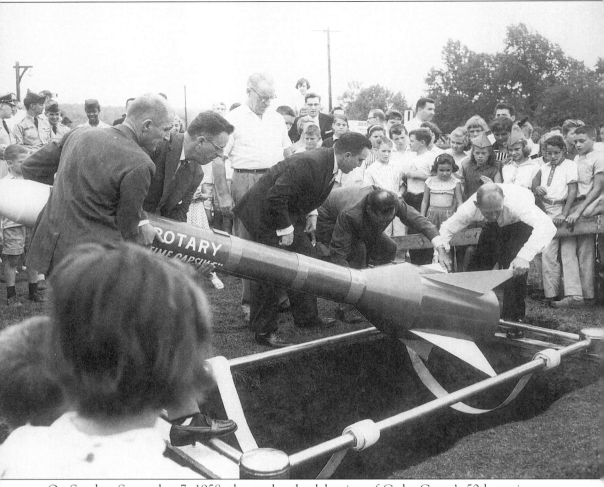

On Sunday, September 7, 1958, the weekend celebration of Cedar Grove's 50th anniversary concluded with the burial of a time capsule by the Cedar Grove Rotary Club. The capsule, constructed by Rotarian Fred Schmidt, was buried on the grounds of the municipal building at 4:00 that afternoon. Among the items in the capsule were "Jubilee Money," on which messages were written for future generations, and the recipe for concocting an Awful Awful, a frosty ice-cream drink sold at Bond's, an ice-cream shop with stores in both Cedar Grove and Montclair. Assisting in lowering the capsule, from left to right, are Jack DuHamel, Jack Straffin, Joe Bianchi, unidentified, and Ed Lentz, holding two of the fins of the capsule.

Formed in Chicago in 1905 as a service organization, Rotary received its name because its meetings were "rotated" at the members' places of business. Today, there are more than 1 million Rotarians, men and women, in 158 countries. The Rotary Club of Cedar Grove, organized in 1937, included among its charter members Canio Cestone, William Crawford, Frank Dailey, Roy Jacobus, and Gus Meier Jr.

Five

TOWN SERVICES

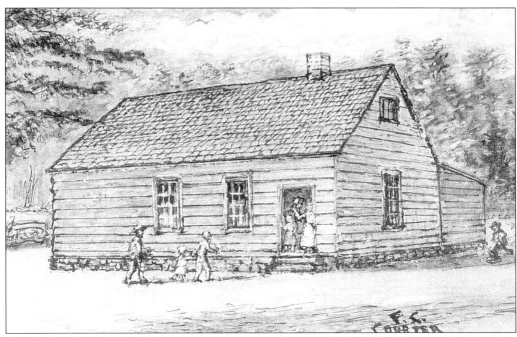

The Cedar Grove School District was incorporated on April 18, 1853. This was the first time that the name had been officially used. The beginning of the official document reads: "The subscribers, trustees of the school district herein after described, situate in the Township of Caldwell, desiring to become incorporated, in pursuance of the ninth section of 'A supplement to the act entitled, an act to establish public schools,' have adopted the name of Cedar Grove."

In existence from 1770 to 1820, the first school was located on the west side of today's Pompton Avenue near where the Public Hall was later be built. The second school, shown in this sketch by Franklin C. Courter, was built on the same site and existed until 1867.

Franklin C. Courter, Cedar Grove's preeminent artist, was born in 1854. After beginning his education in the school that he later sketched, Courter and his family moved to Michigan, where he later graduated from and then taught at Albion College. He is best known for his landscapes and Abraham Lincoln portraits. Courter later returned to Cedar Grove and died at his home at 165 Little Falls Road in 1947.

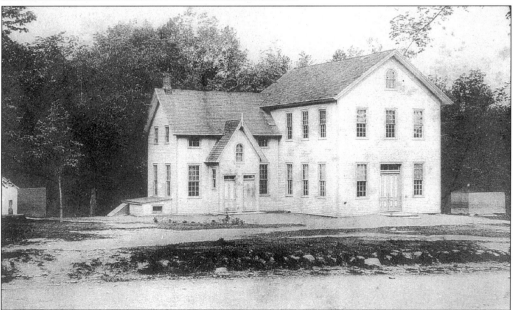

Cedar Grove's third school was on the site of today's Leonard R. Parks School. The structure, a white frame building containing four rooms, was used from 1868 to 1916. A lecture room on the second floor was also used by residents for entertainment and religious services. High school instruction was offered briefly in one of the first-floor rooms.

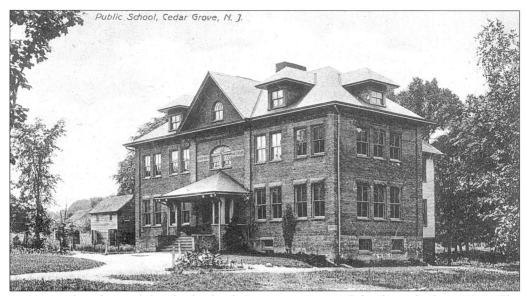

Constructed in front of the third school, Pompton Avenue School was built in 1902. The school's first principal, William N. Bortic, was a Civil War veteran, architect, and teacher. Originally illuminated by gas, a single electric bulb later sufficed for each classroom. Gustav Meier's barn is visible on the left.

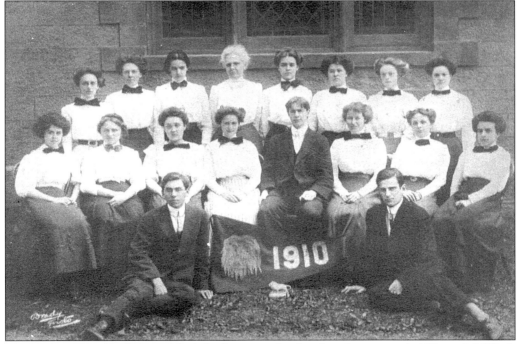

The 1909–1910 school year marked the first time that local students attended Bloomfield High School. Getting there required a ride on the Erie Railroad to Glen Ridge and then a short walk to Broad Street. Elmer Bowden Taylor, seated on the ground at the left, was the only Cedar Grove resident in the 1910 graduating class. He served and died in World War I.

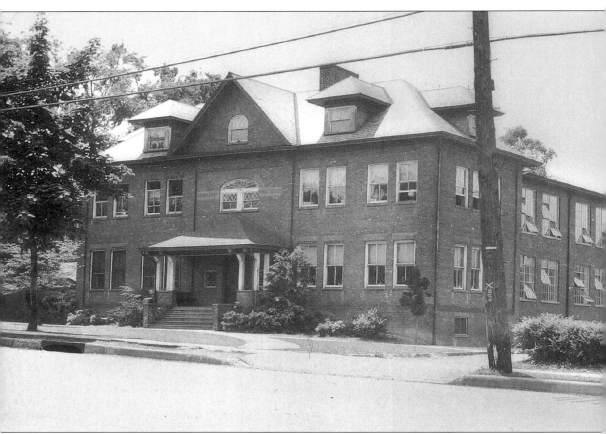

The old white frame building was replaced in 1916 by an eight-room brick addition. Six years later, indoor plumbing was finally installed. By the 1930s, the school's population had outgrown its classroom space and the auditorium had to be used for instruction. Later in that decade, Leonard R. Parks, a former manual training teacher, became principal of Pompton Avenue School. Two kindergarten rooms were added to the rear of the building in the late 1940s. By 1959, the school consisted of 15 classrooms.

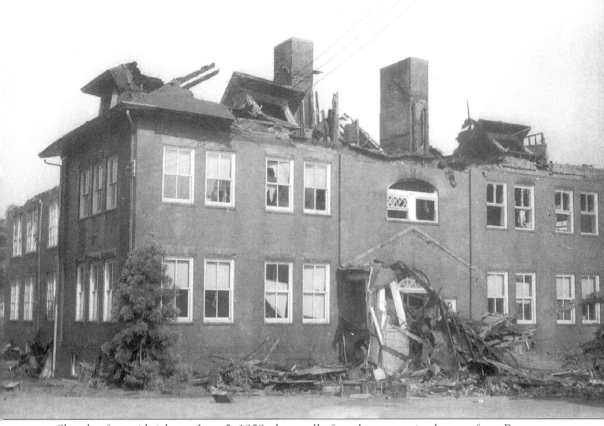

Shortly after midnight on June 5, 1959, the smell of smoke was noticed across from Pompton Avenue School. The smoke was the result of a fire that had started in the basement of the school. After firefighters arrived at the scene, their problems with nearby hydrants necessitated pumping water from the nearby Peckman River. Despite assistance from Verona firemen, the blaze continued for several hours, with several men narrowly escaping injury when the front gable fell to the ground. For the next two years, classes were held at the Old First Church, St. Catherine of Siena, Community Church, Temple Sholom, and the municipal building. The new Pompton Avenue School opened in April 1961. When Leonard R. Parks retired in 1965, the school was renamed for him.

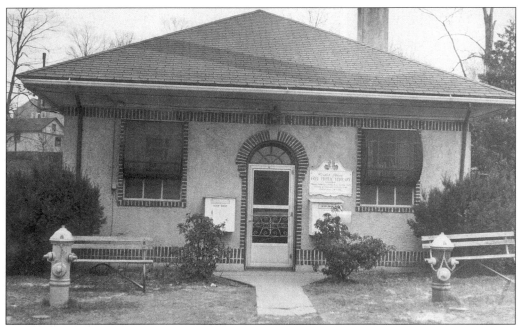

In 1910, a local women's service organization known as the Fortnightly Club voted to establish a small library on Pompton Avenue opposite Union Street. The library was later located in Pompton Avenue School, the Public Hall, and the municipal building. It was then moved to a remodeled pumping station, shown above, at the rear of the municipal building.

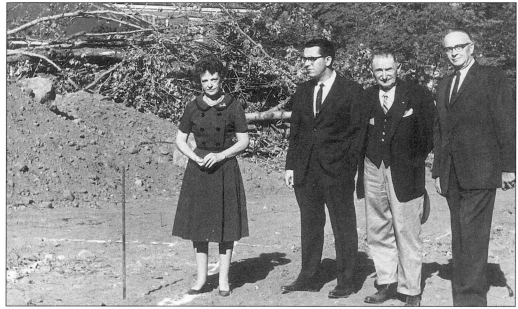

Emilie Curry was appointed director of the Cedar Grove Public Library in 1954. Ten years later, approval was given for the construction of a new library behind the municipal building. Shown at the August 1964 groundbreaking are Emilie Curry, Township Manager John Hohenwarter, and Library Board members Jack Gesell and Reverend Russell T. Loesch.

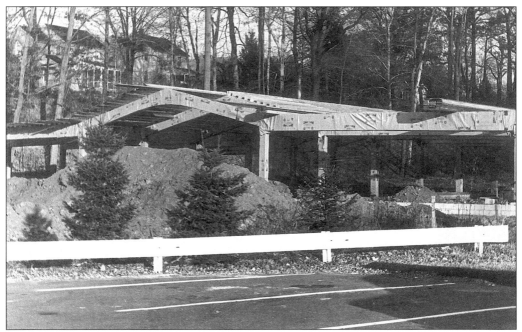

The $150,000 library is shown under construction in the winter following the groundbreaking. Dedication of the new facility occurred on June 13, 1965. In the background are the houses on Rugby Road.

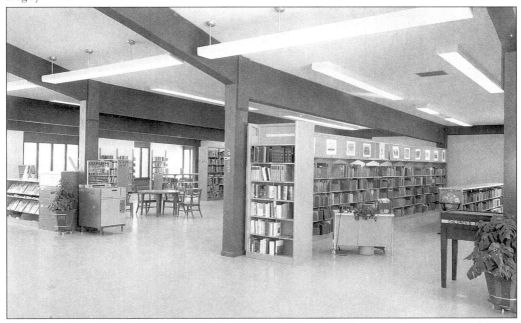

Using a "book brigade," volunteers united to move books from the pumping station to the new library in a single morning. At the right is the Children's Room, where it still is. The copying machine at the left then took 25¢ and 30 seconds to make a single copy. This 1965 photograph was taken by William Cone 57 years after he took his panoramic photograph of Overbrook.

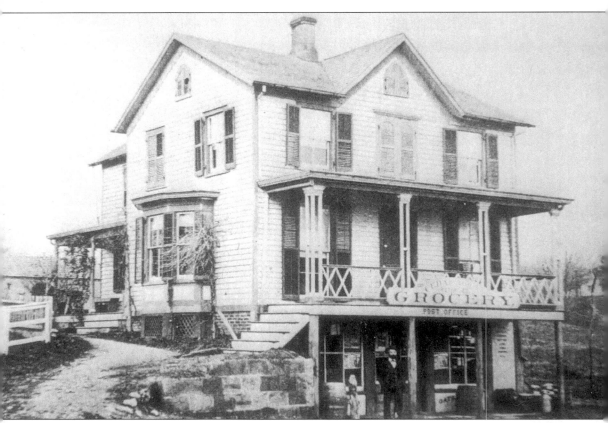

Cedar Grove's first post office was established on January 26, 1874, one year after the Montclair Railway arrived in town. Peter Lee, a Civil War veteran, was the first postmaster and handled the duties in his general store on Little Falls Road near Bortic Road. Lee is shown standing in front of his store, which is now a residence. The postmaster's low annual salary of $12 was of little concern; the position brought additional customers to the store. Mail was brought by cart to the post office from the railroad station on Little Falls Road by Frank Jacobus. Jacobus's son Oscar Jacobus became postmaster many years later.

After the Caldwell Railway arrived in 1891, the post office was relocated to a store on the site of the former Ward Brush Factory. The building, the town's second post office, was destroyed by fire in the late 1890s. Its replacement, the town's third post office, was built on the same site. Photographed after it became a general store, it is shown at the top of page 45.

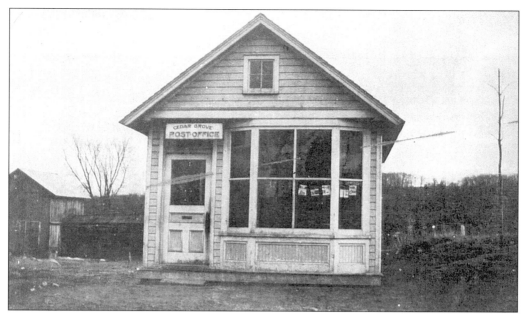

Cedar Grove's fourth post office was originally a butcher shop adjacent to the building that later became Meier's general store. The shop was later sold, placed on a wagon, and moved just south of the third post office. Because of the low railroad bridge, Bowden and Little Falls Roads were used as a detour. The building was used as a post office from 1907 to 1913.

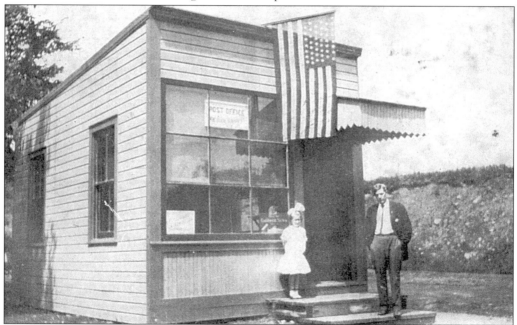

In 1912, Arthur M. Cowie became postmaster and soon bought Sam Brower's barbershop. In July 1913, the building was placed on skids and dragged by horses to the corner of Pompton and Grove Avenues. Closer to the town's population center than its predecessor, the building then became Cedar Grove's fifth post office. Cowie is shown with his daughter Eleanor Cowie.

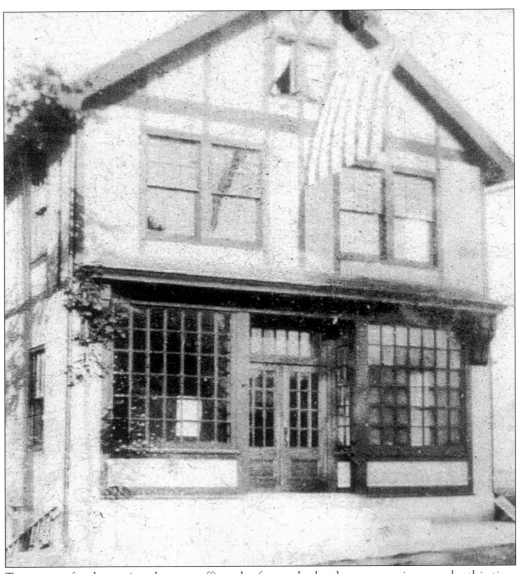

Two years after becoming the post office, the former barbershop was again moved—this time westward to Grove Avenue. On its former site, Arthur M. Cowie erected a building designed specifically for use as a post office. The two-story structure had ample space on the ground floor for both accommodating postal customers and providing additional living space for Cowie and his family. It served as the town's post office until 1939.

Located between the Erie Railroad and the Peckman River, the new location took advantage of both. Post office business increased substantially because commuters could use the facility going to and from work. In those years, mail was received by going to the post office to get it. Cowie may have chosen the location because of the adjacent Peckman River. One of his favorite pastimes was to sit at the kitchen door on the south side of the building and cast his fishing line into the stream below. He was known to his customers as "All Day Cowie" because of a sign in the building that read, "A.M. Cowie, P.M."

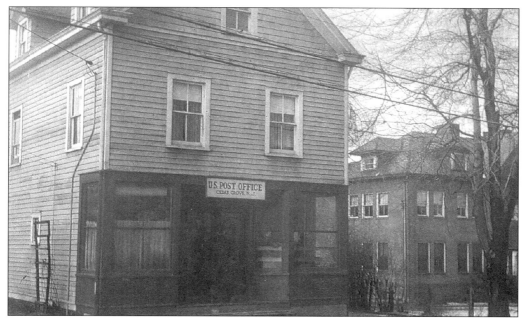

After doing business at the corner of Pompton and Grove Avenues for 24 years, the facility was no longer adequate for serving a significantly larger population. In October 1939, the post office was relocated to Gustav Meier's former store. Meier died the following September. Pompton Avenue School is on the right in this 1949 photograph.

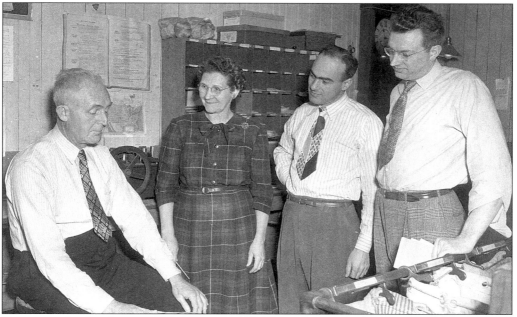

Taken inside the former Meier's store, this 1949 photograph shows, from left to right, postmaster Oscar Jacobus, Elizabeth Singerle, James Paul De Maio, and Bill Sawyer. Jacobus served as postmaster from 1937 until 1959. De Maio, a published amateur songwriter and once a baseball player for the local athletic club, succeeded Jacobus.

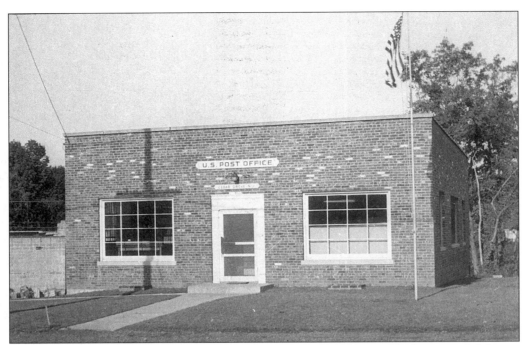

Beginning in the 1930s, there was a strong movement within the town for home mail delivery. By the late 1940s, all federal stipulations had been satisfied except one—the former Meier's store was deemed inadequate by federal postal authorities. To overcome this last obstacle, a new post office was built on Bowden Road opposite Rugby Road in 1949.

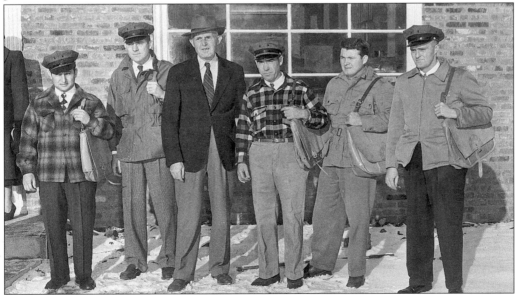

On November 28, 1949, home mail delivery began. Petitions, visits to Washington by postmaster Oscar Jacobus, and a new post office had brought results. Shown outside the post office on the first day of delivery, from left to right, are Louis Gencorelli, John Goosman, Oscar Jacobus, Louis Betz, Vincent Lopez, and Frank Sweigert. Sweigert later became postmaster.

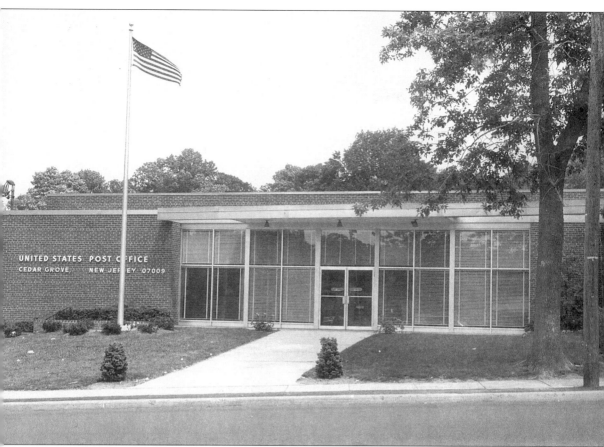

In 1959, after searching for a site for a new postal facility, the town acquired the Frank Bottazzi and William Chesney properties on Pompton Avenue, south of the municipal building. Two years later, Cedar Grove's present post office was dedicated on Sunday afternoon, December 3, 1961. The dedication was preceded by a parade, reputedly the town's largest ever, that began at Johnson's Driving Range on the corner of Pompton Avenue and Commerce Road. Included among the marchers was a 40-piece army band from Fort Dix. After the dedication, a reception was held at the Friar Tuck Inn. James De Maio Sr. was postmaster at the time and remained in that position until 1973. David J. Shatzel has held the position since 1987.

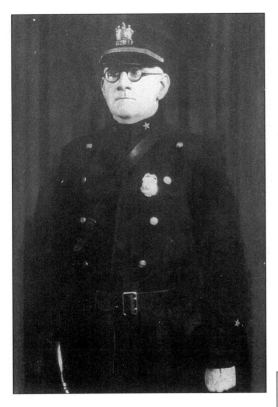

William "Big Bill" Bogan, Cedar Grove's first salaried police chief, served the town from 1924 to 1929. Riding a small brown mare and sporting an exposed pearl-handled revolver, "Big Bill" did not go unnoticed. Legend states that after Bogan was bitten by a rabid dog, the town's muzzling ordinance was immediately enforced. The badge on Bogan's hat reads, "Chief."

Memorial Day ceremonies in 1929 began with a parade followed by a service at Pompton Avenue School honoring those who died in past wars. At noon, across the street, there was a ceremony for the laying of the cornerstone of the new municipal building. Gustav Meier, chairman of the township committee, delivered the remarks. Samuel Boardman awarded the prize for the best float in the parade—a ton of coal. The building was dedicated on September 29 of that year.

.: PROGRAM :.

MEMORIAL DAY
CEREMONIES

IN MEMORY OF OUR WAR DEAD
held on the School Grounds

— and —

Laying of the Corner Stone
of the New Municipal Building

— and —

Parade
Preceding These Ceremonies
CEDAR GROVE — NEW JERSEY
May 30th, 1929

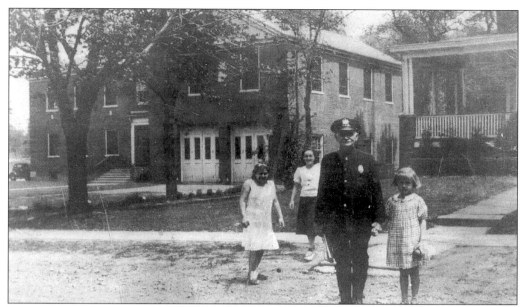

Pictured before Pompton Avenue was widened and paved, the municipal building is shown in 1936. At the right is the home of Dr. Canio Cestone, one of Cedar Grove's first medical doctors. William Steck, a retired cooper and Pompton Avenue School custodian, also served as a crossing guard for the school. Steck lived around the corner on Cedar Street.

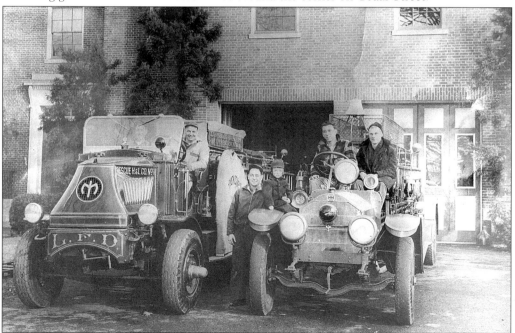

Fire Company No. 1 had its origin at a 1908 meeting in Sam Brower's barbershop. After storing its equipment at Pompton Avenue School and then the Public Hall, the company moved into the municipal building. Shown in this late 1940s photograph, from left to right, are J. Wallace Crawford at the wheel, John High Jr., John High III, William Ward, and Dick Bunten.

In 1954, voters approved a change to a council-manager form of government; four years later, the town celebrated its 50th anniversary. On September 6, 1958, a Grand Ball at the Meadowbrook featured the crowning of Miss Cedar Grove. Pictured, from left to right, are Councilman Melvin Haas, Nancy Smith, Mayor Hedwig Turkenkopf, Deputy Mayor Robert Byrnes, and Councilman Edward Sillcox.

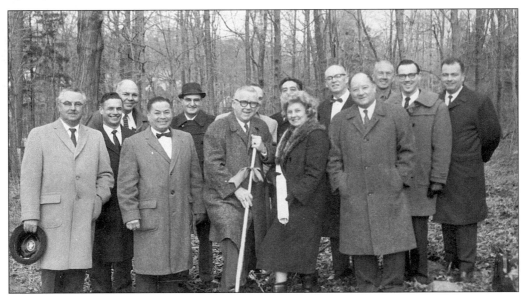

Groundbreaking for the Community Pool took place in the winter of 1962–1963. Participants in the ceremony are Melvin Haas on the left, William Rembert, Melville Lyman, William Maloid, Town Engineer Al Aulicino, Mayor Robert Byrnes, Betty Barton, Edward Nugent, Frank Del Fosse, unidentified, Kennedy Shaw, and Robert Quinn.

In the early 1960s, Marty Liquori of Ozone Avenue was a student at St. Catherine of Siena School. After graduation, Liquori attended Essex Catholic High School and, as a senior in 1968, ran the mile in 3 minutes and 59.8 seconds. One of only three high school runners to break four minutes for the mile, Liquori is also the last. Later at Villanova University, Liquori captured three consecutive NCAA one-mile titles and was the top-ranked miler in the world in 1969 and 1971. Now a resident of Gainesville, Florida, he is the author of several books on running and is often a commentator for sporting events on national television.

Shown with Liquori, front center, at a 1968 dinner at the Friar Tuck Inn honoring his achievements are, from left to right, Villanova teammate Larry James, parens Marty Liquori Sr. and Sara Liquori, and Recreation Department Director John Maher.

In 1973, John Carlotti told his Cub Scout den of the fossil rock that he and his brothers had discovered east of the Bradford Arms Apartments. After the den visited the site, a paleontologist inspected the relic, stated that it was about 370 million years old, and suggested that it be moved indoors. The public works department was asked to assist in the move.

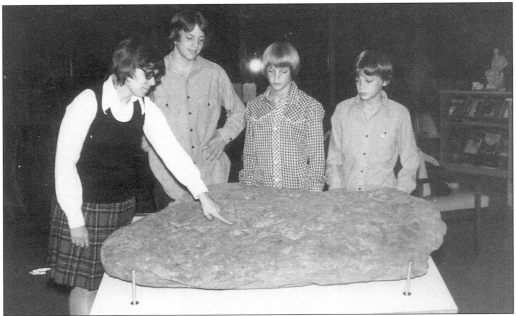

Complete with police escort, the fossil rock was transported to the library in the town's front-loader. On September 15, 1973, a special program was held outside the library, with speeches by paleontologist Robert Salkin of the Newark Museum and Jean Jaeger, one of the den leaders. Shown with the rock are Jean Jaeger, and Carlo, Artie, and John Carlotti.

Six

OVERBROOK

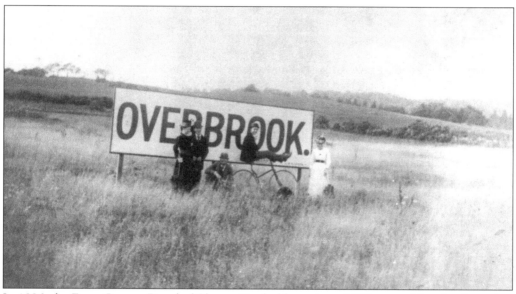

In 1896, the Essex County Board of Chosen Freeholders selected 325 acres of farmland, in what was then Verona Township, for the future site of the Essex County Asylum for the Insane. The land was chosen for the potential therapeutic benefits that the patients received from living in a rural setting. Motivating the decision was the need to abandon the county facility on South Orange Avenue in Newark and move to a location that allowed room for future expansion. After the Newark institution was finally closed, the newer facility was renamed the Essex County Hospital at Overbrook. The name was chosen because the hospital was just over the brook (the Peckman River). This view of the Overbrook property is from Grove Avenue, with the Grosch family in the foreground. Today's Ozone Avenue was known as Grosch Avenue in the early 1900s.

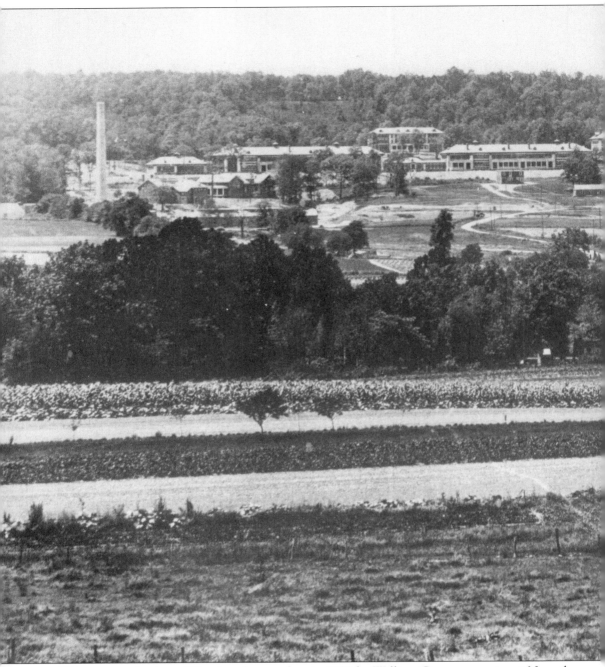

This panoramic view of Overbrook was taken in 1908 by William Cone, a prominent Newark photographer. The building at the base of Second Mountain with five dormers is the Nurses' Home on the west side of Fairview Avenue. To its right, and on the east side of Fairview Avenue, the building with nine dormers is the Administration Building. In the center of the picture are the five Hill Buildings, which contained patient wards. The Star Building, named for its shape and the first building at Overbrook, is at center right. In front of the Star Building

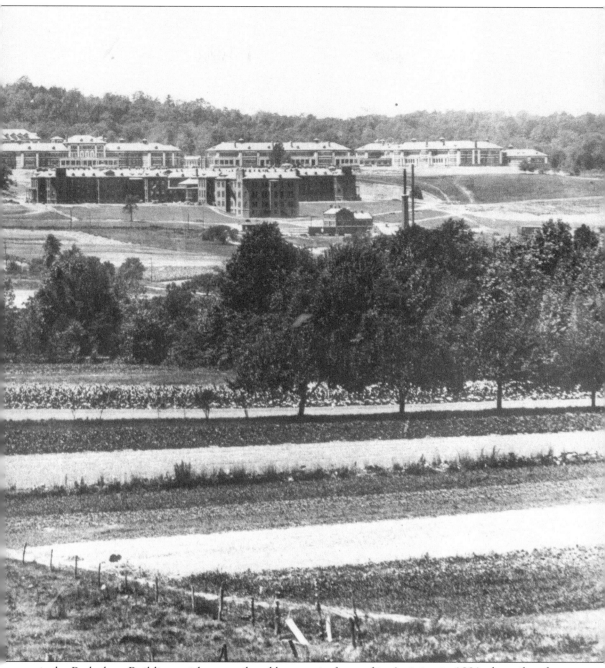

is the Pathology Building, with two railroad boxcars in front of it. Arriving in 1891, the railroad brought in supplies and provided transportation for employees, visitors, and patients. The smokestacks at the left and right were part of the powerhouse complex at each location. Presumably, the latter serviced the nearby Star Building, and the former serviced the remainder of Overbrook. In the foreground are the fields used to grow food for the hospital. (New Jersey Historical Society.)

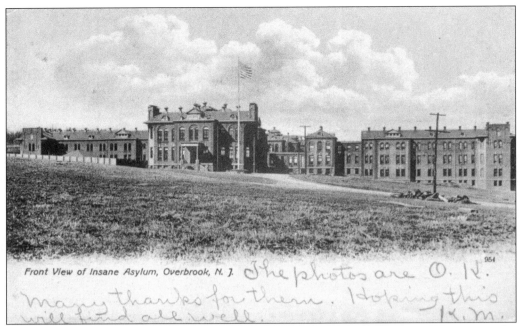

Front View of Insane Asylum, Overbrook, N. J.

The Star Building is shown on this postcard mailed in 1908. Initially housing 400 patients, the two-story iron and brick structure had dayrooms on the first floor and dormitories on the second. Originally for only male patients, it was later expanded for females. The building was demolished in 1979; the site is now occupied by the Calvin Childs Therapy Building.

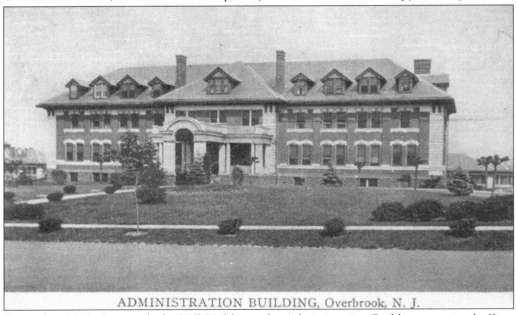

ADMINISTRATION BUILDING, Overbrook, N. J.

Opened in 1909 along with the Hill Buildings, the Administration Building contained offices for the medical superintendent and assistant physicians, a reception room, a medical library, a central dispensary, and a barbershop. It was connected to the Star and Hill Buildings by a corridor. An entrance lobby was added in the early 1960s.

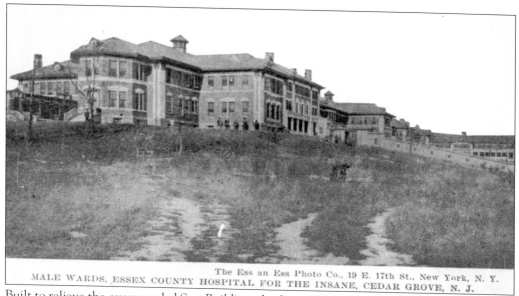

The Ess an Ess Photo Co., 19 E. 17th St., New York, N. Y.

MALE WARDS, ESSEX COUNTY HOSPITAL FOR THE INSANE, CEDAR GROVE, N. J.

Built to relieve the overcrowded Star Building, the five Hill Buildings were connected by a one-story corridor. North of the male wards, on the right, were the female wards. The buildings contained dormitories, dayrooms, dining halls, infirmaries, sun parlors, reception rooms, and porches. The porches were situated to receive maximum sunlight and fresh air.

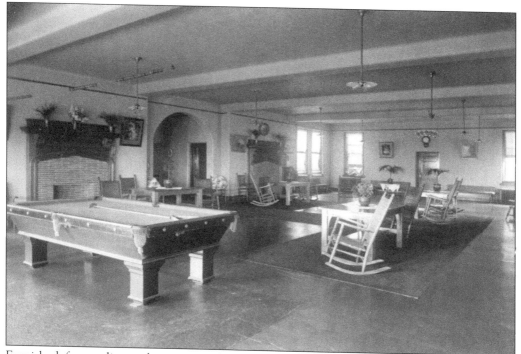

Furnished for reading, relaxation, and recreation, each of the wards at Overbrook had a dayroom. Most of the dayrooms were equipped with working fireplaces, although they were rarely used except for heating emergencies. Both patients and staff used the rooms.

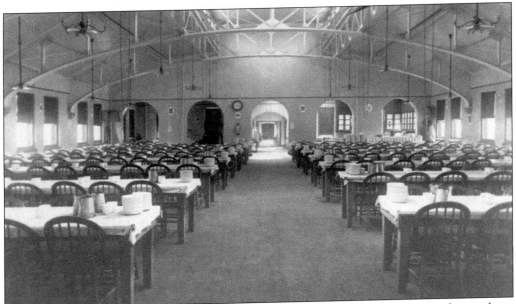

Two dining halls, each with a capacity of approximately 600, were located near the southern and northern ends of the Hill Buildings. In the mid-1950s, four kitchens and a diet kitchen served over 9,000 meals daily. Involved in the preparation were a chef, a dietitian, 12 cooks, 42 service workers, and 20 patients who volunteered to assist.

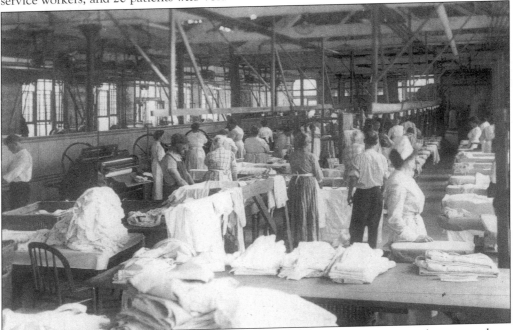

Because of its need for hot water, the laundry was located near the boilers in the power plant. As in the kitchen, patients who were able and willing to work assisted in the laundry as well as the tailor shop, sewing room, greenhouse, and on the grounds. When this photograph was taken c. 1914, there were approximately 1,600 patients at the hospital.

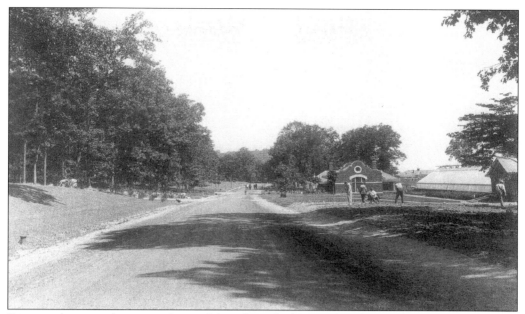

Fairview Avenue, the major thoroughfare through the Overbrook complex, is shown when it was a dirt road. The group on the right is tending to the grounds adjacent to the greenhouse. To the left of the greenhouse is the firehouse. The Overbrook medical staff believed that occupational therapy was the most important factor in patient treatment.

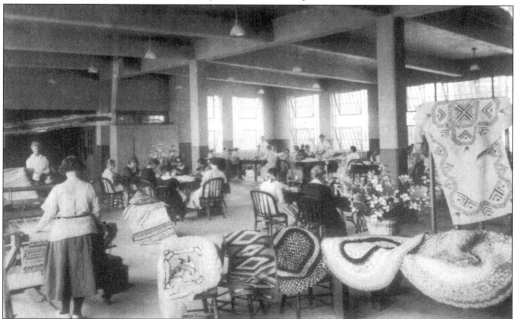

Overbrook was the first mental hospital in the state to offer occupational therapy classes in fields such as pottery making, bookbinding, woodwork, and rug weaving. This scene is in the Industrial Building. In August 1927, approximately 1,000 rugs were taken to the county courthouse and then sold. Patients received a commission on their work.

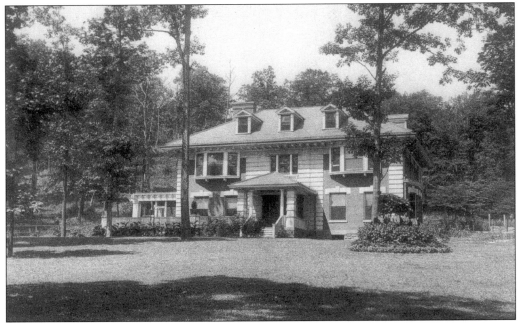

The medical superintendent's home was located on the west side of Fairview Avenue near the southern boundary of the Overbrook property. Dr. Guy Payne served the hospital from 1910 to 1947, except for his service in World War I. His successor, Dr. Hamilton, had an elevator installed in the residence to accommodate his wife, who was an invalid.

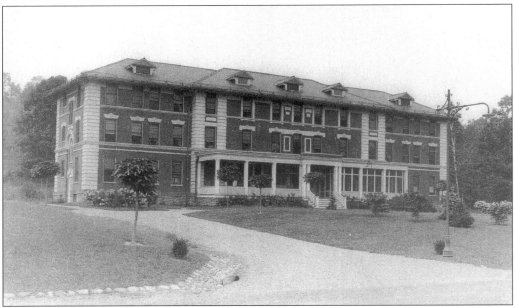

The Nurses' Home was also located on Fairview Avenue. Living rooms, a reception room, parlors, and a library were on the first floor. The residence was connected to the Administration Building by a tunnel under Fairview Avenue. Overbrook was one of the first hospitals in the country to educate nurses in the care of psychiatric patients.

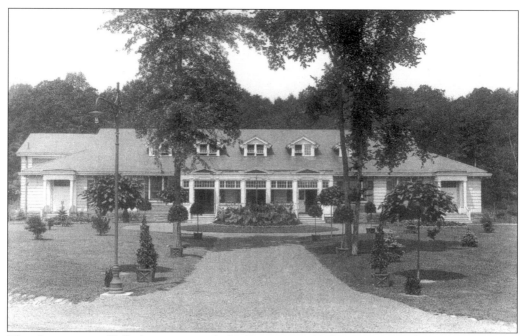

The Amusement Hall, later renamed the Recreation Hall, was across the street from the Administration Building. It was later named the Guy Payne Auditorium. Functioning as theater, gymnasium, and chapel, the building was used by many Cedar Grove organizations such as the Air Raid Wardens, Civic Club, Pompton Avenue School, and the PTA.

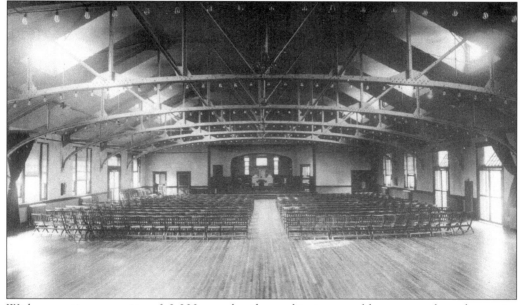

With a seating capacity of 3,000 people, the auditorium could accommodate the entire Overbrook population. At the south end was a stage for dramatic performances; the north end had a movable pulpit used for religious services. The folding chairs could be removed for athletic contests or turned for religious services. The building was razed c. 1970.

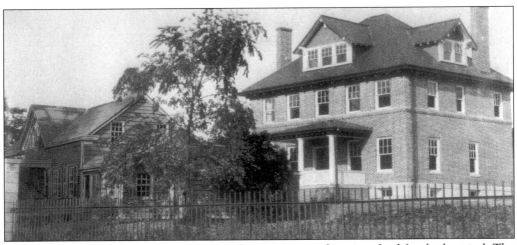

In the early 1900s, acreage abutting Grove Avenue was used to grow food for the hospital. The crops were the responsibility of the Overbrook farmer, who lived on Grove Avenue in the residence on the left. On the right is the new "farmer's cottage" near the end of its construction in 1920. Its $50,000 cost created a controversy. A candidate for Congress that year said that if he had known of the cottage, he would have chosen to run for the position of Overbrook farmer.

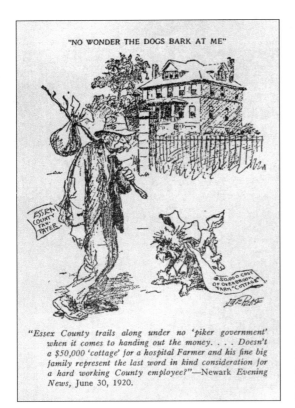

"NO WONDER THE DOGS BARK AT ME"

"Essex County trails along under no 'piker government' when it comes to handing out the money. . . . Doesn't a $50,000 'cottage' for a hospital Farmer and his fine big family represent the last word in kind consideration for a hard working County employee?"—Newark Evening News, June 30, 1920.

On June 30, 1920, the *Newark Evening News* ran this political cartoon. In 1922, the decision was made to convert the farm acreage into additional pastureland for the dairy herd; the following year, the farmer was replaced by a dairyman. The residence is now the home of the Essex County Child Care Center.

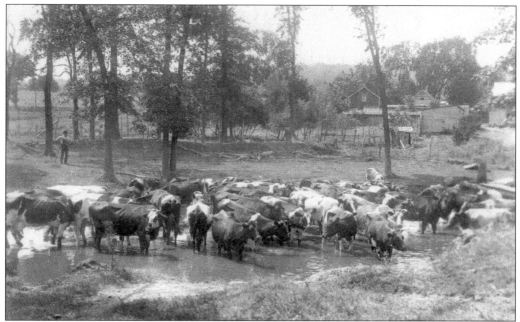

The Overbrook dairy farm was located east of Grove Avenue on the south side of Bradford Avenue. At the time of this *c.* 1914 photograph, all of the milk consumed at Overbrook was supplied by its herd of scrub cows. It was believed that a diet high in milk and butterfat was beneficial to the patients' health.

Eighty cows could be accommodated within the brick barn. Prisoners from the nearby county jail are shown assisting in the milking process. In 1922, registered Holsteins were added to the herd. The barn is now used as the Essex County Public Works Facility. A silo remains just south of the building.

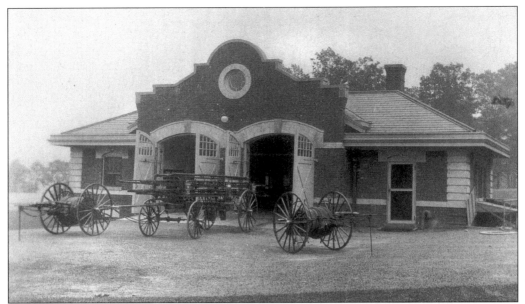

The first firehouse at Overbrook, shown here, was on the east side of Fairview Avenue. In 1915, plans were drawn for a new firehouse across the street that would contain dormitories so that volunteer firefighters could sleep there. The new building, the Fire Apparatus House, is still used today; the older structure now serves as a garage.

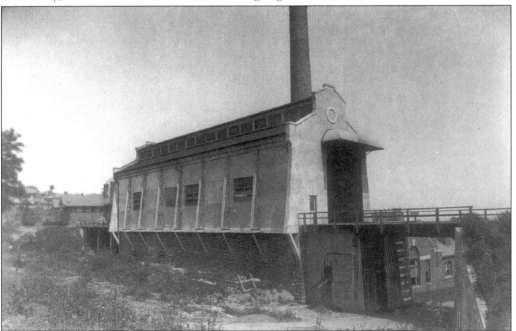

For Overbrook's first 60 years, coal was crucial since the hospital generated its own electricity and heat. Transported to the institution using a spur off the Caldwell Branch of the Erie Railroad, the fuel was delivered to the above coal tipple. The coal was then dumped into the storage bins below. A conversion to oil was made in the late 1950s.

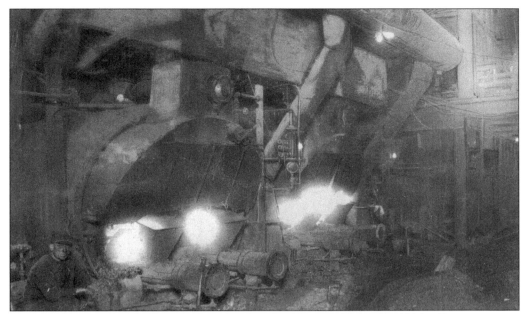

In the early 1900s, six boilers were used to supply power and heat. By 1914, all were in poor condition because of high usage and low maintenance. A series of problems occurred over the next three years, leaving only two boilers operating by December 17, 1917. Although the pair of boilers were sufficient for heating the infirmaries and providing power for light, they were not enough for the whole institution, the rest of which went without heat for three days.

By December 20, 1917, repairs had been completed on the old boilers and work was in progress on installing three new boilers, the first of which became operational on December 31, 1917. The new boilers had overhead bins for the automatic feeding of coal and a conveyor for removing ashes. In 1918, partly as a result of the unfavorable news surrounding the heating problems, those freeholders up for reelection were defeated.

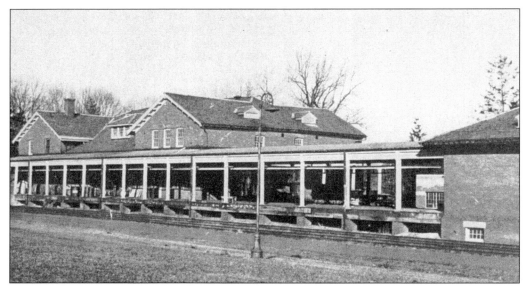

The freight station at Overbrook was located a short distance beyond the coal tipple. The double-tracked siding was used to bring food, clothing, and household necessities from outside suppliers. At the left is the warehouse, and at the right is the bakery.

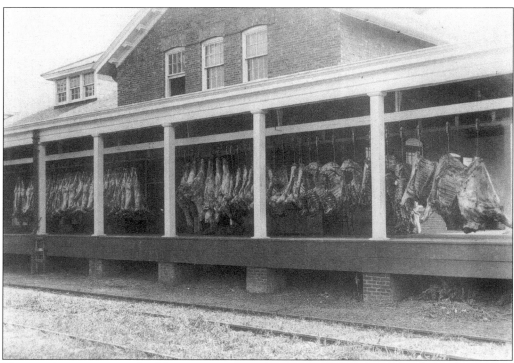

The warehouse contained cold storage rooms with refrigeration produced by an ice plant in the building. With the loading platform adjacent to one of the tracks, food was easily moved from refrigerated boxcars to the overhead hooks and then to the cold storage areas. A butcher shop and nearby kitchen completed the processing.

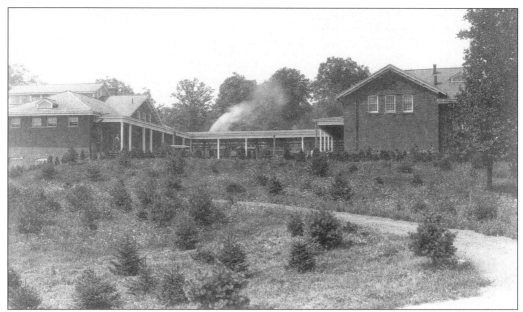

This *c*. 1914 view shows the east side of the warehouse-bakery facility with a steam locomotive on the siding. By the early 1950s, steam power had been replaced by diesel locomotives and, by the end of that decade, Overbrook no longer relied on coal. Although freight service and the warehouse no longer exist, rusted rails still run alongside the former bakery.

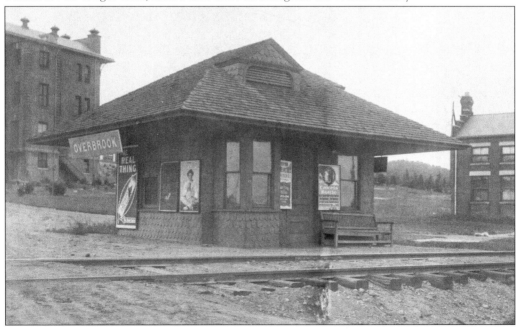

The Overbrook station was the first station built in Cedar Grove on the Caldwell Branch. In this 1909 photograph, the Star Building is at the left and the Pathology Building at the right. Still standing, a nearby milepost reading "JC 19" informs today's passer-by that Jersey City was once 19 miles distant by rail. In the 1930s, Overbrook was dropped from the timetable.

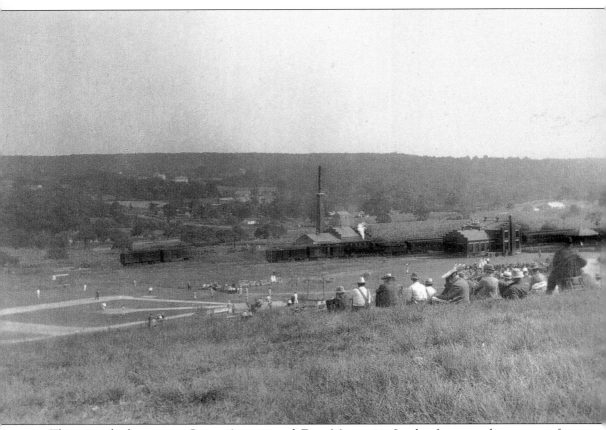

This view looks east to Grove Avenue and First Mountain. In the foreground, a group of spectators are comfortably watching a baseball game from the vantage point of the hillside. Based on the presence of dark-coated umpires on the infield, the contest appears to be an official game. In those years, Overbrook had a team that competed against local nines, such as the Bloomfield Orioles and the Newark Redcaps.

Across the center of this picture is the railroad. Several freight cars are at the left. In the center are a steam-spouting locomotive and several passenger cars, and the Overbrook passenger station is at the right. In addition to supplying Overbrook, the railroad brought staples such as hay, oats, grain, and potatoes to the railroad siding, where they were purchased by local farmers directly from boxcars. The smokestack in the middle of the photograph is atop the power plant used to service the nearby Star Building. Without its smokestack, the building still exists in the weeds east of the abandoned railroad bed.

Seven

ROADS AND RESIDENCES

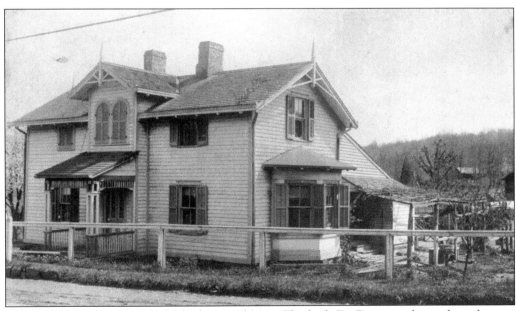

The eight-room homestead of Abraham and Mary Elizabeth De Baun was located on the east side of Pompton Avenue, south of its intersection with Ridge Road. Along with their sons Albert and Ernest, the De Bauns were market gardeners. They made their living by growing crops in the fields adjacent to their home and selling the products locally and in nearby towns. A third son Charles was employed at Overbrook. On November 14, 1918, three days after the end of World War I, the residence was destroyed by fire. The De Bauns soon built a new home at the same location.

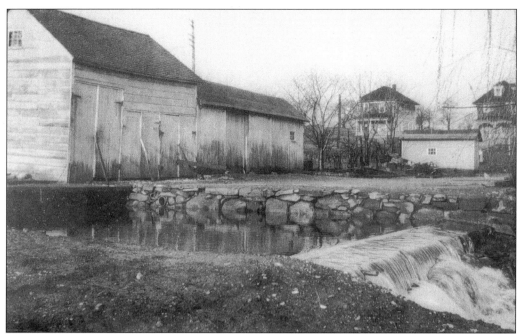

The De Baun property was well suited for farming. Pompton Avenue provided a route to nearby markets, and Taylor's Brook was a source of water. This 1921 view looks west to the homes on Pompton Avenue near Harper Terrace. The second De Baun home and the outbuildings above were razed in the early 1960s; only the dam and some stones lining the brook remain.

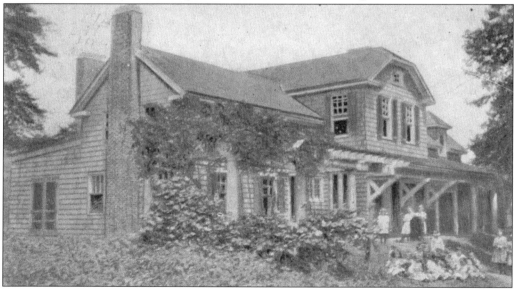

John R. MacArthur owned considerable real estate on the western side of Ridge Road near Pompton Avenue. His property, in addition to the residence above, contained several bungalows used in the summer by children from New York City as a Fresh Air camp. Some of the children are presumably shown at the right. MacArthur's residence was destroyed by fire in 1944.

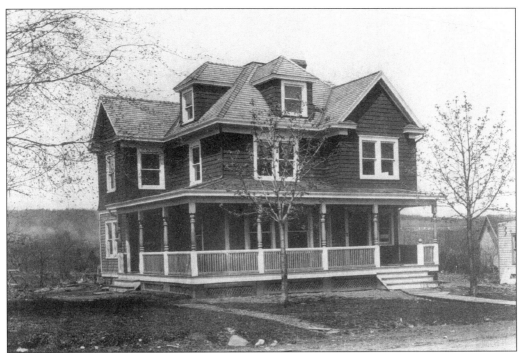

Samuel Brower's home was on the northwest corner of Pompton and Bradford Avenues. His barbershop, partially shown at the right, was the building in which the volunteer fire brigade was first organized and which later housed the post office. The house was demolished in the mid-1960s, and an office building that contained Ray's Pharmacy was constructed.

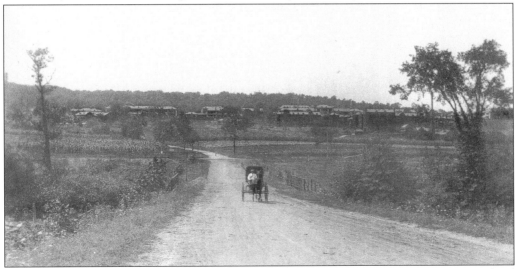

In 1904, Bradford Avenue was extended from Pompton Avenue to Grove Avenue on land that had belonged to the Brower family. In this 1914 view, Overbrook and Second Mountain are in the background and Grove Avenue runs across the center of the photograph. West of Grove Avenue, crops were grown for the hospital. The carriage has just rolled over the Peckman River bridge.

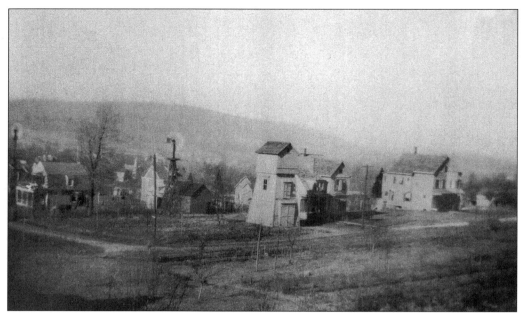

This westward view captures Union Street between Summit Avenue and Eastwood Place in the early 1900s. Not yet extended to Pompton Avenue or Ridge Road, it was presumably called Union because it joined the two streets. Before 1926, Cedar Grove did not have a public water supply, and both windmills and electricity were used to pump water from nearby wells to houses.

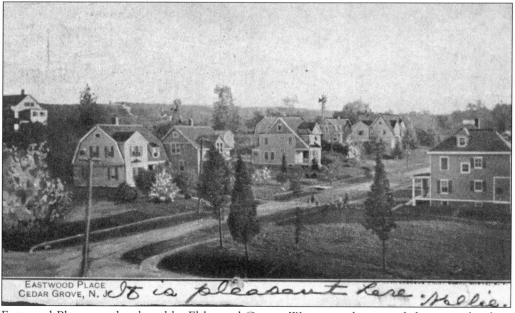

EASTWOOD PLACE
CEDAR GROVE, N. J.

Eastwood Place was developed by Ehler and George Wettyen, who named the street for their uncle Ehler Osterhold (which translates to Eastwood). The houses have not been significantly altered since this postcard was published in the early 1900s. A house on Summit Avenue is at the far left, and the windmills are on Union Street.

The residences on the west side of Eastwood Place are shown c. 1907. William and Edna Bradshaw lived in the house on the right for more than 50 years. Before St. Catherine of Siena Church was built, many local children received their religious instruction in the Bradshaw home from the Sisters of St. Dominic.

Decades later, the houses at the left and center in the view at the top of the page were the residences of the Hunold and Smith families. Eleanor Hunold, right, starred in the locally made 1941 spoof of Hollywood, *The Movie Queen*. Nancy Ellen Smith, left, was named Miss Cedar Grove for the town's Golden Jubilee in 1958. Photographed together in 1942, they have been friends since.

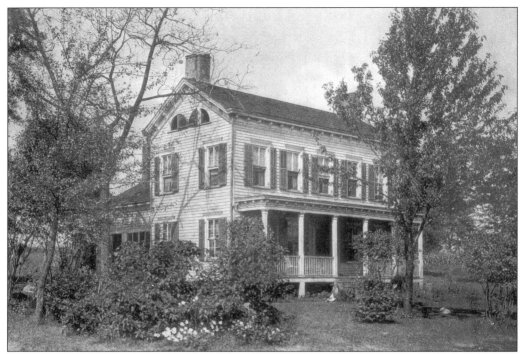

In 1857, George Munch acquired a residence on the west side of Ridge Road south of today's Union Street. The house has been in the Schneider family since the marriage of Munch's daughter Matilda to Carl Schneider. Numerous alterations, including the enclosing of the porch, were made in the late 1920s.

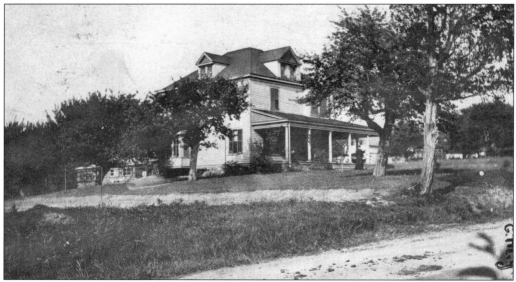

Herbert Holly Jacobus, a commercial artist and engraver, began his printing business shortly after moving to this house on Cedar Street in 1900. The business, later run by his son, Roy Jacobus, was conducted in a shop at the rear of the property. In that building, still existing, *The Observer,* the town's first newspaper, was printed from 1937 until 1948.

112

Originally from England, Edgar M. Wilford became the chief color artist at the *New York World c.* 1900. An active Cedar Grove resident, he was a member of the board of education, the first president of both the Public Hall and Building and Loan Associations, and literally helped build St. David's Episcopal Church. Wilford was killed instantly by an automobile in Brooklyn on July 4, 1916, on the way to visit his son, Rowland Wilford. His funeral was the first to be held in St. David's.

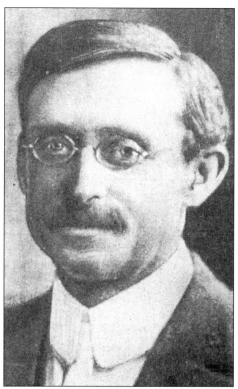

Edgar M. Wilford's home was on Upper Cedar Street, the name in the early 1900s for that portion of the street east of Ridge Road. After Edgar Wilford died, his wife, Lottie Wilford, rented rooms to borders and hunters to obtain income for herself and her five children. Prey for hunters was apparently plentiful; the western slope of First Mountain was densely wooded.

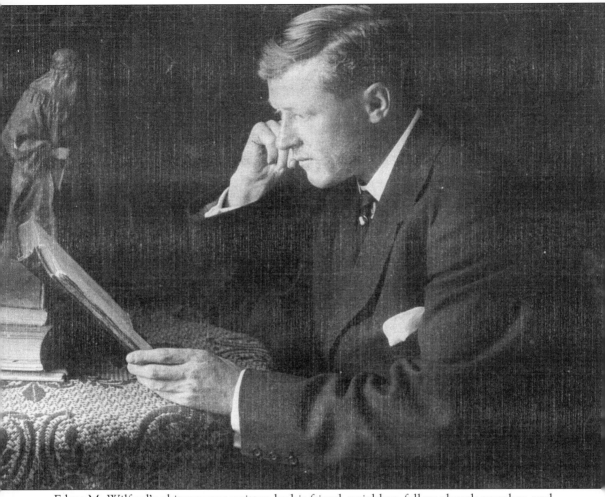

Edgar M. Wilford's obituary was written by his friend, neighbor, fellow church member, and coworker Arthur Wynne, shown above. In it Wynne wrote, "every evening he climbed the long hill leading from the station to his home to find his youngsters waiting for him half way home at the edge of the woods." Wynne would have known this; he and Wilford commuted together to New York City on the Erie Railroad. The station, in Upper Montclair, was the one closest to their homes.

Wynne, who was originally from Wales, immigrated to the United States with Wilford. In 1914, for $3,000, Wynne bought one acre of land from the Wilfords on the eastern end of their property. Together, Wynne and Wilford built Wynne's house on what was then the eastern end of Upper Cedar Street (opposite Sunset Terrace today). The residence later became the home of Samuel Boardman, Cedar Grove's first lawyer, and later Tufton Mason, a physician.

Arthur Wynne was the chief editorial writer for the *New York World*. Once a week, as part of his duties, Wynne created a page of puzzles for the Fun section of the Sunday edition. For the edition of December 21, 1913, Wynne constructed a puzzle having a grid pattern with numbered squares corresponding to numbers. F-U-N was already filled in. Wynne called the puzzle a "word-cross." It was an immediate success. Several weeks later, in preparing for the Sunday edition, a typesetter inadvertently reversed the words in the name of the new puzzle and called it a "cross-word." It has been known as that ever since.

2-3. What bargain hunters enjoy.
4-5. A written acknowledgment.
18-19. What this puzzle is.
22-23. An animal of prey.
26-27. The close of a day.
28-29. To elude.
30-31. The plural of is.
8-9. To cultivate.
12-13. A bar of wood or iron.
16-17. What artists learn to do.
20-21. Fastened.
24-25. Found on the seashore.
10-18. The fiber of the gomuti palm.
6-22. What we all should be.

6-7. Such and nothing more.
10-11. A bird.
14-15. Opposed to less.
4-26. A day dream.
2-11. A talon.
19-28. A pigeon.
F-7. Part of your head.
23-30. A river in Russia.
1-32. To govern.
33-34. An aromatic plant.
N-8. A fist.
24-31. To agree with.
3-12. Part of a ship.
20-29. One.
5-27. Exchanging.
9-25. To sink in mud.
13-21. A boy.

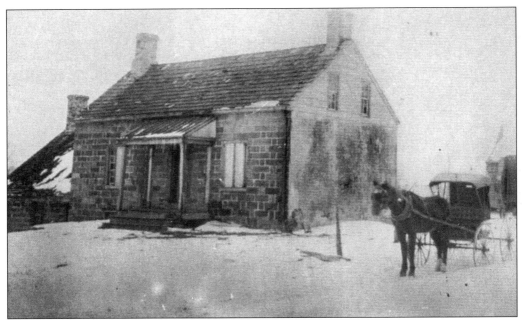

Built by John Vreeland on Ridge Road in the late 1700s, this house of Dutch Colonial design was later inherited by the Taylors through marriage. Constructed of both squared and rubble brownstone, the house originally had one story and an extension containing a kitchen on the southern end. This photograph is from the late 1800s.

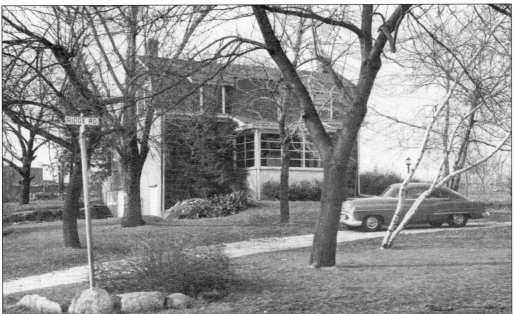

A rear kitchen and second floor with gambrel roof were added in the early 1900s. In the 1950s, a large portion of the land formerly used by the Taylor dairy herd was sold to the town and an enclosed front porch was added to the house. Keith and Sally Honaman acquired the residence in 1979 and later constructed a two-story barn on the site of its vanished predecessor.

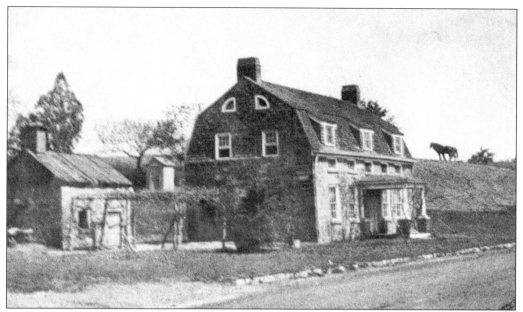

Grove Avenue, one of the first roads through Cedar Grove, was first called Peckman Lane and then Gould Lane. In the mid-1700s, Roeloff Jacobus built his home near the northern end of the road. Much of his original property was later used for Overbrook. The building on the left was used both as a summer kitchen and smokehouse.

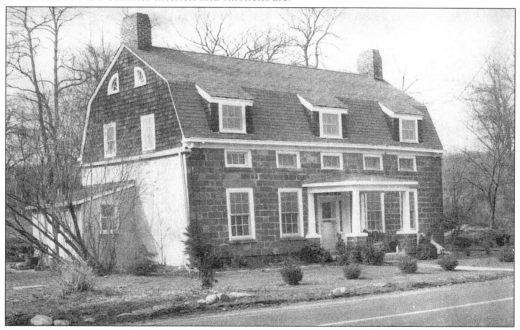

The Jacobus home was built of brownstone quarried in Little Falls. As was true of many Dutch houses, the front of the house was comprised of finely cut blocks, but the remaining walls were built of rubble and mortar stuffed with sand and animal hair for insulation. The house remained in the Jacobus family until the 1880s.

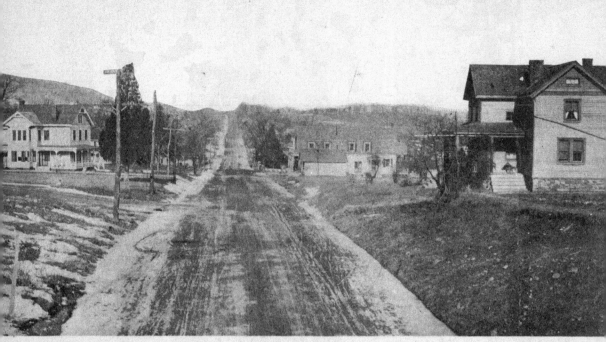

The Ess an Ess Photo Co., 19 E. 17th St., New York, N.

POMPTON AVENUE, CEDAR GROVE, N. J.

This c. 1909 postcard view of Pompton Avenue, looking north, was taken from the Erie Railroad bridge. The utility poles helped bring electricity to the township in the late 1890s. At the left is the Smith residence. Allie and Annie Smith, sisters and spinsters, made mops at home using cotton yarn that had been brought to their home on spools from the Bowden mill.

In the upper center is that part of Pompton Avenue known as Canfield's Hill. Benjamin and Grace Canfield's home was at the top of it. Pompton Avenue was maintained in those years by first spreading limestone on its surface and then oil. Opposite the Smith home was the general store and post office. The house on the right was the residence of Ed and Alberta Miller. The site is now occupied by the Cedar Grove Ambulance and Rescue Squad building.

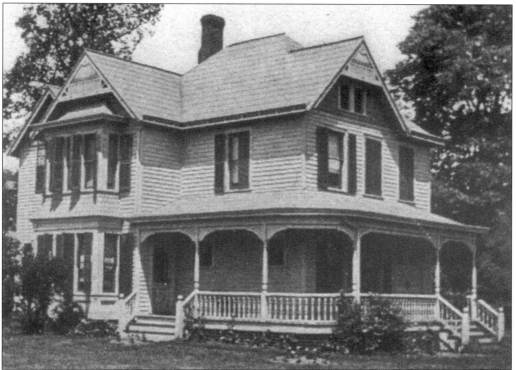

John C. and Elizabeth Young moved from Newark to Cedar Grove in the 1890s. Their home was north of the Smith house and is just visible in the previous postcard view. Located on what later became Young Avenue, the house is little changed from its above appearance in 1910, except for its porch, which is now enclosed.

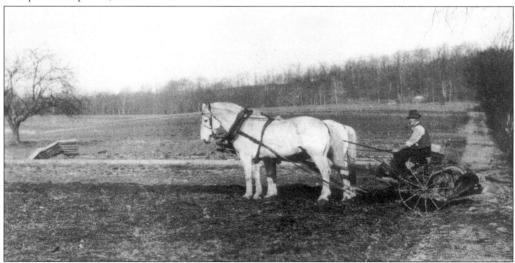

John C. Young, a farmer, is at work c. 1920 on the 28 acres that he owned west of his home. Beginning in the late 1920s, his son Joe Young began using the farmland for homes on what later became Myrtle and Young Avenues. Some of John C. Young's descendants reside on Young Avenue west of the original homestead.

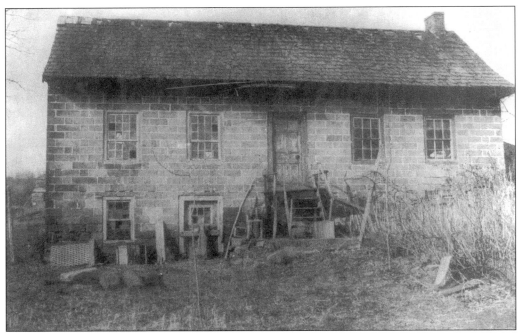

George Personett, of French Huguenot descent, built a brownstone house in 1771 that faced east on the "olde roade to Little Falls." The Newark and Pompton Turnpike, today's Pompton Avenue, did not exist when the house was built and did not receive a charter until 1806. This photograph shows the front of the house in the 1930s, after years of neglect.

By the 1940s, the house had come under new ownership, the main artery through town was Pompton Avenue, and the "olde roade" alongside the house had vanished. The entrance was then moved to the Pompton Avenue side of the building, and the original doorway was made into a large window. Later bought by the Friar Tuck Inn, the house is now used for weddings and special occasions.

The former Jacobus homestead on the corner of Pompton Avenue and Brunswick Road has changed considerably since 1900. While retaining its different-width clapboards, a wraparound porch has been added and the roofline altered. Isaac Jacobus, an expressman and the owner of the property in the early 1900s, presumably used the wagon lettered "Cedar Grove" in his business.

John Brower is holding the reins in this 1898 photograph taken outside his home on the west side of Little Falls Road, near today's Community Park Road. Brower was the brother of Sam Brower who owned the town's first barbershop. While the house in the background no longer exists, the former Brower residence, somewhat altered over the years, still stands.

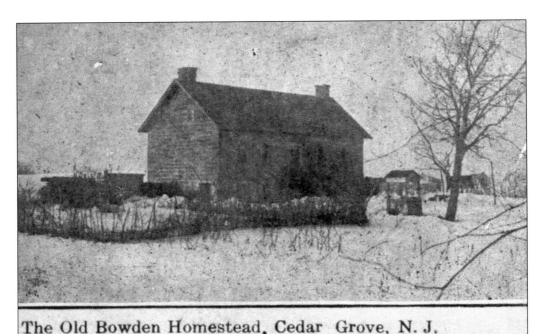

The Old Bowden Homestead, Cedar Grove, N. J.

Built *c.* 1780 by Jacob Van Riper, this brownstone house on Bowden Road was initially used as both a private residence and tavern. In the 1820s, the house was bought by John Bowden, the owner of the nearby cotton mill. Constructed about a decade after the Personett house was built, and perhaps its closest neighbor then, the two houses are very similar.

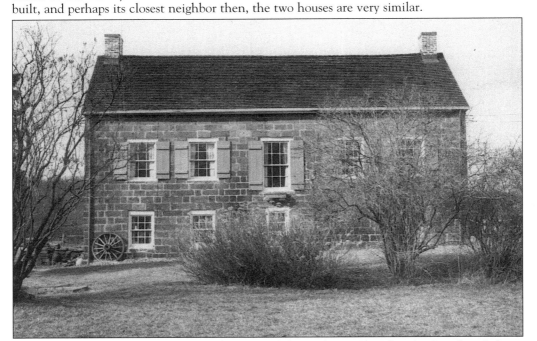

The house remained in the Bowden family until the early 1940s. After the Bowdens left, an addition was constructed at the rear of the house. In 1964, straw mats discovered in the attic suggested that the house may have served as both inn and tavern in its early years.

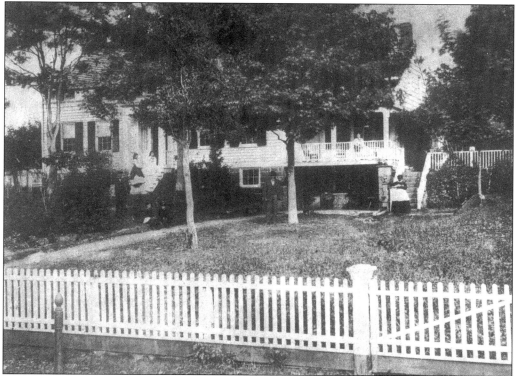

In 1840, John Bowden built a new home on Little Falls Road across from his cotton mill. By the early 1900s, Bowden's son and daughter-in law, Anthony and Eliza Bowden, resided in the family homestead. John Bowden's grandchildren Lewis G. and William later became the last Bowdens to retain family ownership. This photograph was taken in the late 1800s.

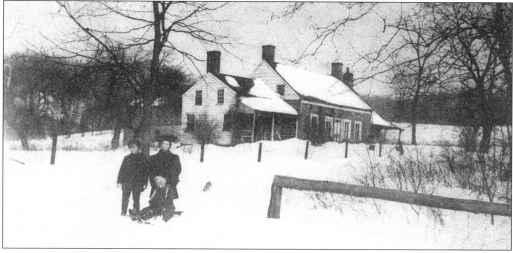

Across from where John Bowden later constructed his second home, Ralph Post built a brownstone Dutch Colonial residence in 1793. In 1918, the house was destroyed by fire; a successor was built five years later. Owned by the Cedar Grove Elks Lodge 2237 today, the initials R.P. and the year 1793 are inscribed in brownstone next to the front door.

At the crest of the hill on the Newark and Pompton Turnpike, Benjamin Canfield erected his farmhouse *c.* 1845. Corn, apples, and other crops were grown on the 14-acre property and then sold at local markets. James and Edith Morgan bought the property in 1910 and continued the Canfield farming tradition. This photograph is from the late 1800s.

After her husband's death, Edith Morgan and her son Courtenay Morgan became well known for the produce they sold off their front porch. In the early 1980s, the son arranged for the property to be eventually deeded to the township. The Cedar Grove Historical Society continues the Morgan tradition with its annual fall Pumpkin and Apple Sale.

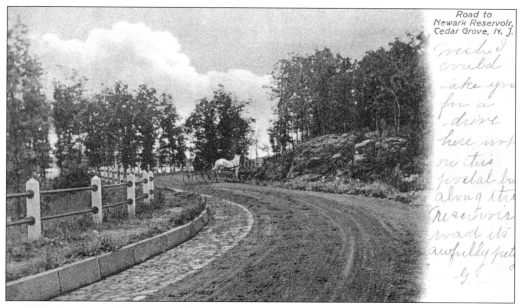

In 1899, the City of Newark purchased land in Cedar Grove for a new reservoir. A spur from the Caldwell Branch was used to bring in materials, and a narrow-gauge railroad was used for construction. Operations began in 1905. The message on this card reads, "Wish I could take you for a drive here, not on this postal but along this reservoir road it's awfully pretty."

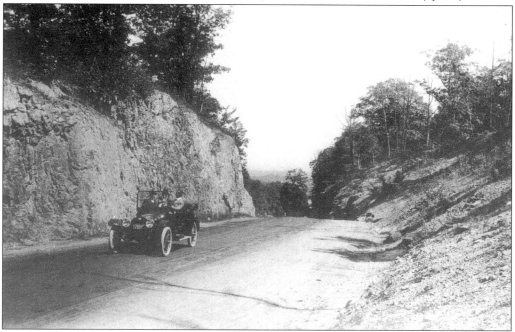

In 1907, the grade on Bradford Avenue was reduced from 17 to 9 percent and the road was paved. It was the most expensive stretch of road building, per foot, in the state that year. The longest sleigh ride in town began at the top of the hill, went west to Pompton Avenue, and then turned north to Little Falls Road and the corset factory. This view is c. 1914.

Allen Balcom Du Mont was born in Brooklyn, New York, in 1901. He moved to New Jersey with his family and later graduated from Montclair High School. In 1924, he received a degree in electrical engineering from Rensselaer Polytechnic Institute and after graduation went to work for the Westinghouse Lamp Company in Bloomfield. He went on to join the DeForest Radio Company in Passaic and became its vice president, resigning later to devote full time to his research in the area of television. This photograph was taken during his junior year at Rensselaer.

In 1931, the Allen B. Du Mont Laboratories were incorporated with the goal of developing a more reliable and larger cathode-ray tube. After hiring two glassblowers, Allen Du Mont began research in the garage of his home at 9 Bradford Way in Cedar Grove. The only known photograph of his laboratory shows Du Mont between his two employees.

INTRODUCING Alec Electron . . .
Television's Master of Ceremonies.

You'll get to know Alec much better
when post war electronic appliances
become a part of your every day life.

Television will be one of the greatest industries to emerge from the present conflict, just as radio expanded after World War I.

For many years, Allen B. DuMont Laboratories, Inc., have been engaged in both the receiving and transmitting phases of television. Du Mon't station WABD has been in continuous operation for more than three years, is now on the air three evenings each week.

Each picture appearing on the screen of your Du Mont Television-Radio Receiver will fill your home with a kind of delight you probably have dreamed of many times. It will literally bring the world to your fireside.

You have waited a long time for television. You want the truest, clearest kind of instantaneous reproduction over the air.

Accept nothing less than DuMont quality!

DuMont *Precision Electronics and Television*

ALLEN B. DU MONT LABORATORIES, Inc., 2 Main Avenue, Passaic, New Jersey

In 1938, Du Mont marketed the first totally electronic television set. This advertisement for Du Mont Laboratories appeared in 1944. On May 2 of that year, WABD (named from Du Mont's initials) received its commercial license. Later that year, the station was assigned to Channel 5 in New York City. One of its most popular shows was *The Original Amateur Hour* with Ted Mack. Du Mont television sets (known then as telesets) were attractive, substantial, and of high quality. WABD went off the air in 1955. Allen B. Du Mont died a decade later.

Traces of Allen Du Mont's laboratory remain today in his former home. Perhaps blown out by the glassblowers, two windows in the garage were replaced by cement blocks decades ago. Plugs that helped support conduits for gas, electricity, and water still remain embedded in the walls. An electrical wire that was attached to a motor for a rooftop antenna still protrudes from a first-floor interior wall. Perhaps reflecting Du Mont's electrical background, a small room on the top floor contains an abundance of electrical outlets. The outlets were put to good use in the writing of this book. Allen B. Du Mont's former residence has been the home of the author and his wife, Jean, since 1986.